# THE SECRETS TO CREATING AMAZING PHOTOS

## 83 COMPOSITION TOOLS FROM THE MASTERS

Marc Silber

Copyright © 2018 Marc Silber

Published by Mango Publishing Group, a division of Mango Media Inc.

Photo credit: Unless noted, all photographs are by Marc Silber.

Cover and Layout Design: Elina Diaz

Mango is an active supporter of authors' rights to free speech and artistic expression in their books. The purpose of copyright is to encourage authors to produce exceptional works that enrich our culture and our open society.

Uploading or distributing photos, scans or any content from this book without prior permission is theft of the author's intellectual property. Please honor the author's work as you would your own. Thank you in advance for respecting our author's rights.

For permission requests, please contact the publisher at:

Mango Publishing Group

2850 Douglas Road, 3rd Floor
Coral Gables, FL 33134 USA
info@mango.bz

For special orders, quantity sales, course adoptions and corporate sales, please email the publisher at sales@mango.bz. For trade and wholesale sales, please contact Ingram Publisher Services at customer.service@ingramcontent.com or +1.800.509.4887.

The Secrets to Creating Amazing Photos: 83 Composition Tools from the Masters

Library of Congress Cataloging

ISBN: (print) 978-1-63353-766-8 (ebook) 978-1-63353-767-5

Library of Congress Control Number: 2018937914

BISAC category code: BISAC category code PHO012000 PHOTOGRAPHY / Techniques / Lighting

BISAC category code PHO016000 PHOTOGRAPHY / Subjects & Themes / Portraits & Selfies

Printed in the United States of America

"Once again, with this book, *The Secrets to Creating Amazing Photos*, Marc Silber proves to be a wonderful and worthwhile compendium of photographic knowledge, tips, tricks, survival skills, and historical perspective. This book is a go-to collection of lucid composition strategies and tools for any photographer who is striving and seeking to up their game in the fast paced endeavor known as digital photography."

—**Joe McNally**, internationally acclaimed, award-winning photographer

"Buy it, read it and then apply what you have learnt from this superb new book, *The Secrets to Creating Amazing Photos* by the respected award-winning photographer, writer, educator and professional video producer Marc Silber. This is a complete must-have, a veritable cornucopia of wisdom gained over decades of experience."

—**Gray Levett**, editor Nikon Owner magazine

"This is the book we've all been waiting for—a concise and compact guide covering a full spectrum of composition tools, just the size you can bring with you for inspiration in the field. Marc Silber offers immensely valuable knowledge acquired as an accomplished photographer and from years of interviews with many of America's finest image-makers. Presented in brief concise chapters, this friendly book leads us clearly and gracefully from the basics to advanced techniques in photography composition. For anyone interested in raising the quality of their photography, this book is highly recommended."

—**Brian Taylor**, Executive Director, Center for Photographic Arts

"With his very full library of videos, Marc Silber has written books that make this wealth of knowledge easily assessable to any photographer. His most recent book tackles the very important subject of composition in an innovative way: Marc described and illustrated techniques from the works of many masters of classical art and photography, resulting in 83 tools to help develop your individual style and voice. This new book is an important contribution to the photographic community. Use it well to broaden the expression of your art."

—**Michael Adams**, M.D, The Ansel Adams Gallery

"Composition is perhaps one of the most misunderstood elements of photography. Even when consciously breaking compositional rules, it's important to master the rules and understand what they are and how they enhance a photograph for maximum impact. Professional photographer Marc Silber lays out an easy to follow course of action to help you understand what composition is and why it's important to understand both the basic rules and the more advanced compositional techniques so you can enhance the presentation of your own work."

—**Thomas Hawk**, Photographer

"Anyone can have gear, but knowledge and practice depends on you, if you want to become a better photographer. This book gives you knowledge and ideas to practice your photography like the masters, with composition examples which can be applied until they become natural to your eyes and mind."

—**Guillermo Villar A.**

"This book is a great read and wonderfully informative. It opened my eyes to how photography still plays on basics of art explored by master painters over centuries—reminding us again that photography is a singular tool within the arts of imagery. Wonderfully explored and explained by one of today's greatest photographers and teachers. Thanks, Marc!"

—**Ron Prokop**

"The popularity and accessibility of photography are at an all-time high, but within the masses of image makers are those looking for a deeper understanding of the process of photography itself. There are those looking for the unique, the original and the knowledge required to craft remarkable moments. Marc Silber's *The Secrets to Creating Amazing Photos* details and describes the compositional building blocks of successful photographs. Great photography requires commitment, education, practice and even luck. Silber's book is a roadmap to the starting line."

—**Daniel Milnor**, photographer

"To really understand composition, you need to learn how your camera sees the world, how each of the different elements within the image interact with each other and how energy flows between them. It is the energy flow that sets the mood and takes your audience on its journey through your composition. When you get it right it turns a snap into an awesome image irrespective of what camera you are using. Marc Silber's new book *The Secrets to Creating Amazing Photos* sets out the composition guides and tools as well as composition mood lines that will teach you how the elements of your image interact, how to arrange them and how you can create a mood with the flow of energy through the composition. As with all skills, it takes practice, and yes; more practice, but with this guide you will start to see the world around you in a very different way and you will start on the journey taking your photography to the next level. Enjoy the journey!"

—**Quentin Whitfield**, An enthusiastic photographer

"Marc's book is a great resource for anyone using any type camera at any level. If you are thinking about the image that is being captured and how to understand why some images standout more than others, why you feel a certain way about what you experience, Marc has a way of explaining this.

The technical functions of a camera can be learned by anyone and this resource will guide you through "rules" that can be incorporated into any scene or subject. For me I also found that some of the ideas I had were reinforced. Reading it a few times over, I was able to pick up a different point of view when I am out in the field and add some elements that improve my image making.

Extremely valuable book to have on hand, and the only read I have seen that explains what seems all of the composition guidelines in the one publication. Thanks Marc"

—**Marty Strecker**, Photographer

# TABLE OF CONTENTS

Foreword 12
Preface 14
How to Use This Book to Create Amazing Photos 20
Acknowledgements 24

**PART ONE:**
**FUNDAMENTAL COMPOSITION GUIDES AND TOOLS** 27

1. Framing: Put an Edge around It 30
2. Landscape Format 33
3. Portrait Format 34
4. Turn at an Angle 35
5. Points of Thirds 36
6. Geometry Can be a Pleasure 39
7. Leading Lines Direct Attention 41
8. Diagonal Lines Can Add Movement, Interest, and Vitality. 43
9. Symmetry Can Delight the Eye 46
10. Capturing the Decisive Moment 47
11. Punctuation Points In your Photographs 48
12. Capture a Gesture at the "Decisive Moment" 49
13. Angles Are Like an Author's Choice of Words 50
14. Viewpoint: How You See Your Subject 56
15. Steelyard Composition Is Balanced 62
16. "L" Shape Composition 64
17. Grouped Shape Composition 66
18. Three Spot Composition 70
19. Silhouette Composition 72
20. Tunnel Composition 75
21. Patterns Can Be Engaging 77
22. The Golden Ratio Proportions 80
23. S-Curve Composition Leads the Eye Gracefully 84
24. Circular or "O" Composition Invites the Eye to Stay Within 86
25. U-Composition Invites You to Look Within 89
26. Triangle Composition Provides Stability and Strength 91
27. Radiating Lines Lead to the Center of Interest 95
28. Cross Composition and Eye Movement 98
29. Balance Scale Composition 101
30. Find Contrast In Your Image 103
31. Fill the Frame by Getting Close to Your Subjects 106
32. Pull Back to Capture the Story 109
33. Place Dominant Eye in the Center of Photo 112
34. Use Color as a Powerful Composition Tool 114

**PART TWO:**
**COMPOSITION LINES THAT CONVEY MOODS IN YOUR IMAGE**
**Mood Lines Convey Feelings or States of Mind**     **117**

35. Active     118
36. Passive     122
37. Structural, solid, strong     123
38. Nonstructural, fluid, soft     124
39. Stable     125
40. Unstable     126
41. Stable     127
42. Unstable     128
43. Positive, bold, forceful     129
44. Tenuous, uncertain, wavering     130
45. The vertical—noble, dramatic, inspirational, aspiring     132
46. The horizontal—earthy, calm, mudane, satisfied     134
47. Primitive, simple, bold     135
48. Effusive     136
49. Flamboyant     138
50. Refined     139
51. Jagged, brutal, hard, vigorous, masculine, picturesque     140
52. Curvilinear, tender, soft, pleasant, feminine, beautiful     141
53. Rough, rasping, grating     143
54. Smooth, swelling, sliding     144
55. Decreasing, contracting     145
56. Increasing, expanding     146
57. Dynamic     147
58. Static, focal, fixed     148
59. In motion     149
60. Meandering, casual, relaxed, interesting, human     150
61. Erratic, bumbling, chaotic, confused     151
62. Logical, planned, orderly     152
63. Flowing, rolling     153
64. Formal, priestly, imperious, dogmatic     154
65. Rising, optimistic, successful, happy     155
66. Falling, pessimistic, defeated, depressed     156
67. Indecisive, weak     157
68. Progressive     158
69. Regressive     159
70. Rise, attainment with effort, improvement     160
71. Fall, sinking without effort, improvement     161
72. Indirect, plodding     162

| | | |
|---|---|---|
| 73. | Concentrating, assembling | 163 |
| 74. | Dispersing, Fleeing | 164 |
| 75. | Broken, interrupted, severed | 165 |
| 76. | Direct, sure, forceful, with purpose | 166 |
| 77. | Opposing | 167 |
| 78. | Connecting crossing | 168 |
| 79. | Parallel, opposing with harmony | 169 |
| 80. | Excited, nervous, jittery | 170 |
| 81. | Opposing with friction | 171 |
| 82. | Diverging, dividing | 172 |
| 83. | Growing, developing | 173 |

**PART THREE:**
**PUTTING YOUR TOOLS TOGETHER AND FINAL TIPS** — **175**

Endnotes — 180
About the Author — 182

# FOREWORD

We are currently living in one of the most exciting times in the history of photography. With the advent of digital processes, photographers are no longer confined to producing photographs that fit a nineteenth century definition of what a photograph is, or can be. As a result, the potential for growth in the medium has never been greater—and the sheer number of photographs being currently produced serve as more than convincing evidence of that growth.

Yet, photography remains one of those decidedly mercurial pursuits in which technology is combined with aesthetic decision-making in order to produce a result that will not only meet a sustained level of technical excellence, but will *also* communicate an aesthetic message that can potentially resonate with an audience. After all, photography is—at its most fundamental level—a form of communication.

Determining whether or not effective communication is being successfully achieved through the medium of photography often boils down to what Edward Weston referred to as: *The strongest way of seeing*. It therefore follows that the strongest way of seeing demands the most effective use of photographic visualization and composition. And of course, this is where the more mercurial aspects of photography begin to present themselves.

As photographers, we continually strive to improve our decision-making process in relation to visualization and composition by more effectively negotiating each successive compositional hurdle

that inevitably arises with each new photograph. And it is the efficacy of *that* specific decision-making process that remains one of the keys to successful creative photography.

Marc Silber has been devoted to helping photographers to more successfully negotiate many of the visualization and compositional hurdles associated with the act of producing creative photos. Having been interviewed by him several times in the past, it has been rewarding to share my insights and tips about photography issues that range well beyond the choices of gear. I've found that Marc is able to probe the more meaningful depths of photography: composition, visualization, and ultimately, the goal of more effective communication—regardless of what camera one might choose to use. As such, it is no surprise that he has turned to writing books in order to present some of the key insights accumulated through his extensive library of in-depth video interviews.

Throughout this book, *The Secrets to Creating Amazing Photos*, Marc presents a compendium of basic tools that can lead to more successful photographic composition and visualization. Each of his 83 distinct suggestions is presented in an easily digestible format and there are plenty of photographic examples to help illustrate the various points he has chosen to emphasize.

For any photographer who has wondered about the keys to producing successful creative photographs, this book is a must-have.

### Huntington Witherill

*Huntington Witherill is a fine-art photographer, visual artist, and workshop instructor based on the Monterey Peninsula, in Central California. To find out more about Huntington, please visit his extensive online gallery and website at: www.huntingtonwitherill.com*

# PREFACE

"A PICTURE IS A POEM WITHOUT WORDS"

—HORACE, ROMAN LYRIC POET

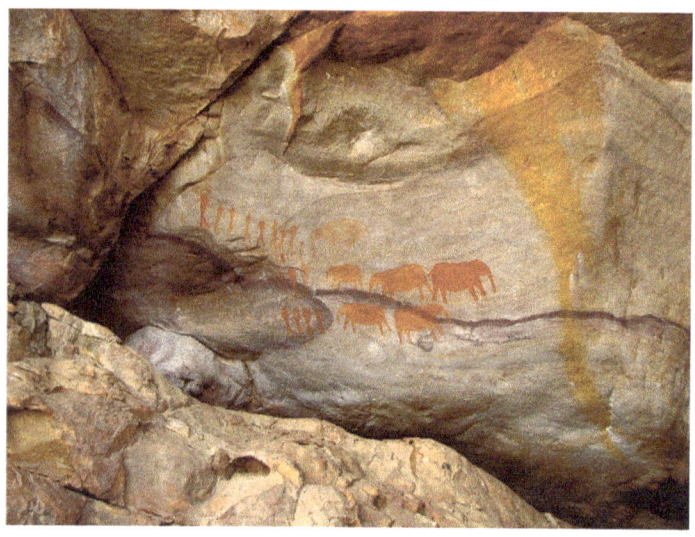

>> San Rock Art, Cederberg, South Africa, as old as 6,000 years

No matter what type of camera you're using, and this most definitely includes smartphones, there are two key skills you must master to make creative photos that you and others will love: how you compose your image, coupled with your use of light.

These skills have been with us ever since the first caveman had a breakthrough and figured out that scratches on a cave wall could communicate to others what he saw or imagined.

This breakthrough of picture making, and others that followed, opened the way to a most powerful urge we all share: to tell our stories to others. It must have been an exhilarating moment when that door began to open and, like our modern tech breakthroughs, it no doubt spread through the other caves at lightning speed! Imagine you and I in a cave, now having the ability to tell each other about what we each saw and even felt. Since we were using pictures, we were able to break though the communication barriers of our limited language.

From that moment, man had a superior communication system to all other life forms on the planet: as individuals, groups, and as a species we could now tell stories to each other in picture form.

But soon, it was not enough to just crudely scratch. Being what we are, man is always looking for the secrets to effectively tell stories. From scratches to rock art, they kept pushing the available technology further and further. And this very definitely embraced composition: how these pictures depicted and reflected life all around them.

Moving forward through the ages, all advances of picture making built on and expanded these initial breakthroughs. The urge to make pictures and share them with others runs deep within mankind. When you take the very long view, is it any surprise to see the explosions we've witnessed with our "modern" picture sharing outlets of YouTube, Instagram, Facebook, and whatever else has come along by the time you read this?

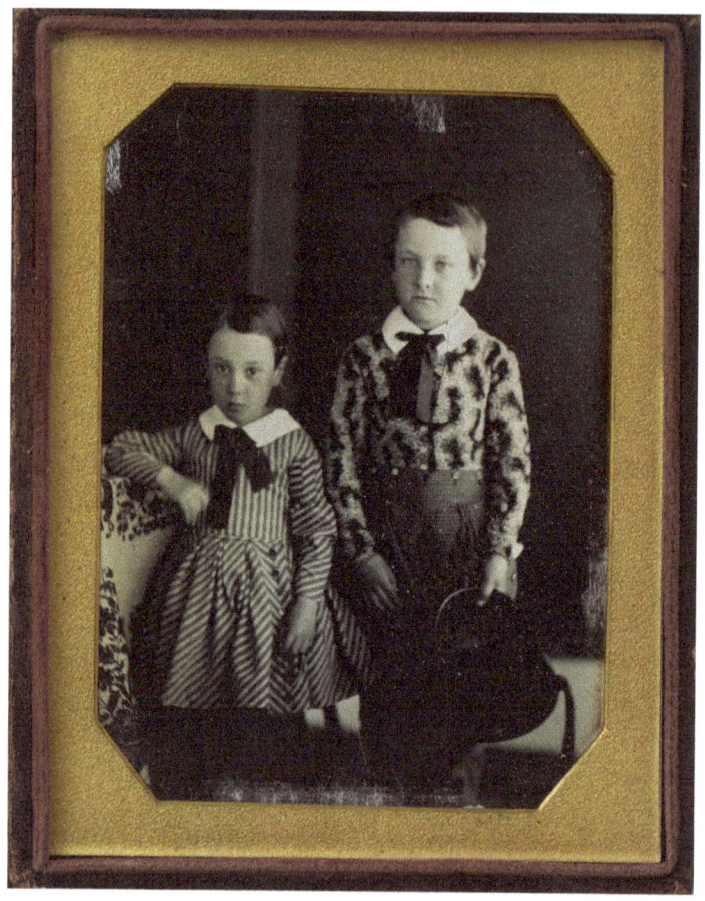

» **Daguerreotype Portrait, 1845, Courtesy Rijksmuseum, Amsterdam**

When photography was first being developed in the mid-nineteenth century, by early pioneers such as Louis Daguerre who invented the "daguerreotype," exposure time could be about fifty seconds to ten minutes, and the developing process was very complex. These early versions of photography were complicated and cumbersome, so the average person was not

going to go through the painstaking process to make a single photograph of sometimes questionable quality. It was easier to stick with drawing, sketching, or possibly painting as the available technologies of the common person at the time.

» **Kodak "Brownie" Camera**

A major breakthrough came when George Eastman (who went on to found Kodak in 1888) embraced photography and figured out a means to put a camera in the hands of anyone in the western world, have them take photographs, and then make prints easily and quickly. This again resonated deeply and it seemed that everyone soon had a camera. From the release of the inexpensive Kodak "Brownie" in 1900, to the much more sophisticated models, photography had become mainstream, which was a major advance in story telling and sharing through pictures.

This boom in photography kept right on going like a massive ocean swell that surfers love so much: a long beautiful ride—that

is, up until the year 2000, the peak of film photography, when an estimated 85 billion photos were taken that year alone.
The newest technology, which had been in its crude infancy, was now coming of age and beginning to be a viable alternative to film. This resulted in a whole new swell on a new order of magnitude with digital photography. Now you could forget about taking your rolls of 12 or 36 exposures to the drug store or camera shop to get them developed: you could look at them instantly on the back of your camera. And when other breakthroughs of the Internet intersected with this, the door opened to instant sharing of our stories anywhere on the planet. A long way from one caveman to another, but nonetheless the same urge.

Then the biggest breakthrough to date occurred in 2007 when Steve Jobs released the iPhone. For the first time in history we had a workable camera that you were always going to take with you everywhere, because it was your phone. The genie was out of the bottle and advances in all smartphones have continued at an ever-increasing rate. Now we have a whole new order of magnitude of picture-making, with an estimated 1.2 trillion photos to be taken this year alone, as of this writing. Compared to the peak of film, there's an increase of fourteen times. But with this explosion of photography and the number of pictures being taken and shared, is the quality of the work going up commensurately? Doubtful, right?

With all these technological advances driving our seemingly unquenchable thirst to make and share pictures, there are fundamental skills that are required to tell the story that both you and others will love. As you've seen, it's not about the latest technological breakthrough, because at every point in man's

sentient history there has been an adequate means to make pictures and share them.

But what makes the difference between a snapshot that you *take* and a real photograph that you *create*? The first answer is visualization, which I covered in detail in my last book *Advancing Your Photography*. A photographer, who controls the process, first gets a vision of the image he or she wants to create and *then* takes steps to capture it.

This leads us to the next answer, which is the subject of this book. When you capture a photograph, you are composing a two-dimensional image within the frame of your camera.

This reveals a key skill that man has been using (or not) since those first scratched drawings: composition. When that first cave artist discovered that there were techniques to change perspective, dimension, viewpoint, and—most of all—emotion, this was the moment that art was born. Now it was the artist who could interpret life and show others what they saw and even felt.

I wanted to take a very long look, so that you can see we're dealing with the deepest of subjects when we're talking about composition, which is why I decided to tackle it with this new book. My goal is to give you a set of tools for composition in one compact handbook that you can carry with you on your journeys and refer to often, like your favorite cookbook in your kitchen, or—stating it another way—a large set of tools in your kit. Here's to your discovery of new skills and continued advancing of your photography.

**Marc Silber**
Carmel, CA

# HOW TO USE THIS BOOK TO CREATE AMAZING PHOTOS

» **Hermanus, Western Cape, South Africa**

### "EVERY PICTURE TELLS A STORY DON'T IT?"

### —ROD STEWART

While every picture has the potential to tell a story, some really do and others ... not so much. The photos that make you stop, look, and say "amazing" are the ones that tell their story the best.

And then there are the photos you pass by that don't seem to have much to say at all ... or do they?

No matter what camera you're using, the two main skills to tell *your* story are composition and lighting.

There is a common misconception that composition is either intuitive or a *gift* that you have or you don't, which can tend to block someone from learning about it. Another block comes from the pendulum swing from two extremes:

A. There are no rules to composition, you just sort of "feel" your way there; or,
B. There are nothing but rules and "laws" that will give you a formula to make your photo look amazing.

I believe that neither extreme is correct and, as with most things in life, the middle course is where you want to be. The way this works out is that you should know the composition *guides*, become familiar with them just as a musician learns his scales, and then start to practice until they come naturally to you and you can fluidly and, yes, intuitively work with them. But before you get to that stage it helps to have structure and a guidebook. This entire discussion holds true for use of natural lighting as well.

First of all, let's define **composition**: It means how you place your subject or subjects within the frame of your camera in order to best tell your visual story. The derivation of composition in Latin is "put together." You're putting the subject of your photograph together in your camera space in order to communicate what you saw and felt to your viewers.

Composition is similar to cooking, where the same ingredients can be combined in a number of ways for a wide variety of

outcomes: flour, baking powder, salt, water, and butter can be made into pancakes for breakfast, or biscuits for lunch, or an angel food cake for dinner. The same basic ingredients, with many different outcomes.

As you'll see, there are many core ingredients to composition that you can use individually or in combination, with the same subjects to tell your story in an infinite number of ways.

Let's think of these as "recipes" or tools that you can learn to use and have at your fingertips. The more fluid you are with them, the more you'll be able to utilize them in imaginative ways to make creative photos. I'm making these easily available to you to help you expand your creative skills in each.

As you'll see, the book defines 83 composition tools for easy use, each illustrated by one or more photographs or other works of art. As a note, these illustrations serve several purposes: first to show the tool being discussed, but also you'll find many interesting examples of composition that you can learn from. For some, I selected paintings going back many centuries to underscore the duration of these tools from the masters.

## THERE ARE THREE WAYS TO USE THIS BOOK:

1. Start at #1, study each tool, and then create your own examples all the way through the book. Then you'll have real experience with each of them.
2. Read through the book to get a feel for these and take notes on the ones that resonate with you. Once you've done this, the best action to reinforce the concepts presented is

to immediately pull out your camera or phone and try to create with that composition "recipe." Since the book is compact, I want you to carry it with you and put it right to use as you're going out and photographing—it's not meant to sit on a shelf and gather dust.

3. The third approach would be—just as if you were learning French cooking from Julia Child—looking through the book to find a recipe that catches your eye, and then simply cooking it. You might be challenged by one and put yourself to the test to see if you can make a credible version of it, and hopefully find you exceeded your expectations.

In any case, my goal is to broaden you skills as a photographer, no matter what level you are when you enter this process. I want to help you fulfill that deep urge that I spoke of to tell stories with your pictures and share them with pride as prints, exhibits, in books you create, on your social media, and elsewhere.

Then, start sharing your photos with us so we can see your results and hear your stories behind your images. To do so, use the hashtag #AYPClub (as I started with my previous book *Advancing Your Photography* (*AYP*).

# ACKNOWLEDGEMENTS

> "WHEN I WAS A KID, THERE WAS NO COLLABORATION; IT'S YOU WITH A CAMERA BOSSING YOUR FRIENDS AROUND. BUT AS AN ADULT, FILMMAKING IS ALL ABOUT APPRECIATING THE TALENTS OF THE PEOPLE YOU SURROUND YOURSELF WITH AND KNOWING YOU COULD NEVER HAVE MADE ANY OF THESE FILMS BY YOURSELF."
>
> —STEVEN SPIELBERG

I want to give a hearty thank you to all the people who helped me research and write this book. It began with the many photographers who generously shared their advice with me, especially to Bob Holmes for his wonderful way of describing what has become instinctive to him. To Kim Weston, for graciously inviting me to his home to discuss his wisdom and to explore his grandfather Edward's legacy. To Bambi Cantrell, Camille Seaman, and David Smith for their composition advice.

Thank you to Michael Zagaris, Bob Holmes, Florian Schulz, David Smith, John Todd, and Jake Garn for allowing me to use their images. To Pete Hoffman, Corey Waldin, and Andrew Hagood for assistance with illustrations. To Gary Meisner for helping me navigate the golden ratio.

I want to give a shout out to branding wizard David Brier for his spot-on coaching. To my wife Jan, for modeling and art directing

the cover and for the millions of other magical things she does to enable me to write and create.

And to my many beta readers who helped me shape the book, especially Cathy Weaver.

I very much want to acknowledge those authors who provided inspiration and content for the book: William Palluth and John Ormsbee Simonds, for their collection of composition formats that form the major framework for the book.

And a big thank you to the team at Mango Publishing, especially Chris McKenney for his vision and encouragement, to Hugo Villabona, for editing and guidance throughout, and Elina Diaz for her beautiful design.

And finally, thank you again to my followers and readers who have supported me over the years. I love your passion for photography. I'm always thrilled to help you continue to advance and I dedicate this book to you!

# PART ONE: FUNDAMENTAL COMPOSITION GUIDES AND TOOLS

"COMPOSITION IS SIMPLY THE ARRANGEMENT OF YOUR SUBJECT MATTER WITHIN THE CONFINES OF YOUR PICTURE SPACE."

—WILLIAM PALLUTH, ARTIST AND AUTHOR

The Oxford American Dictionary defines composition as, "the artistic arrangement of the parts of a picture."[1]

Always keep in mind that composition means how *you* arrange *your* subject within the frame of your camera in a way that best tells *your* story.

Also note that when I say "camera" I'm referring to any type of usual camera or smartphone (you'll see many of my photos in the book were taken with an iPhone which I noted in the caption.) Almost all cameras produce a rectangular image, but a few are square.

You're the captain of the ship when it comes to composition: you have an enormous number of choices for placing your subject within the frame of your camera and one of the adventures of photography is discovering new ways to do that creatively. My goal is to help you do so easily, even intuitively, by practicing with these tools.

As a note, whenever you hear or see the phrase "take" Photos, I'd rather you think of it as *creating* them.

The following are your 83 guides or tools for composition. You'll be able to find many more, but I'm giving you the main ones that will get you rolling, and leave it to you to keep discovering more.

Also remember that, like basic ingredients that I mentioned, these too can be combined in different creative ways. Keep in mind that many of the examples I will show you are *components* of composition, and some of them on their own may not seem

"amazing" but when you add them to your tool kit and put them to work you'll find they become very handy in developing your eye.

Going back to the kitchen, when learning to cook you take up each part of a meal up separately. For example: when learning to make a basic omelet, it might not be much to sing about by itself, but it then becomes "amazing" when you add the other ingredients (cheese, onions, sauces, etc.) when chosen well.

But let's begin by learning each on its own.

I'm going to take these tools up, set by step, beginning with the simplest first, building as we go. If you've been photographing for some time you will be familiar with many of these tools. But please keep your mind open to reinforce or learn new aspects of each. The biggest mistake one can make is to see a familiar tool and then assume that there's nothing more to learn. I have found the reverse is true: the more I study a subject the more I appreciate and can learn from its basics; after all, "basic" means the foundation, which, like a house, must be strong to build upon.

## 1. FRAMING: PUT AN EDGE AROUND IT

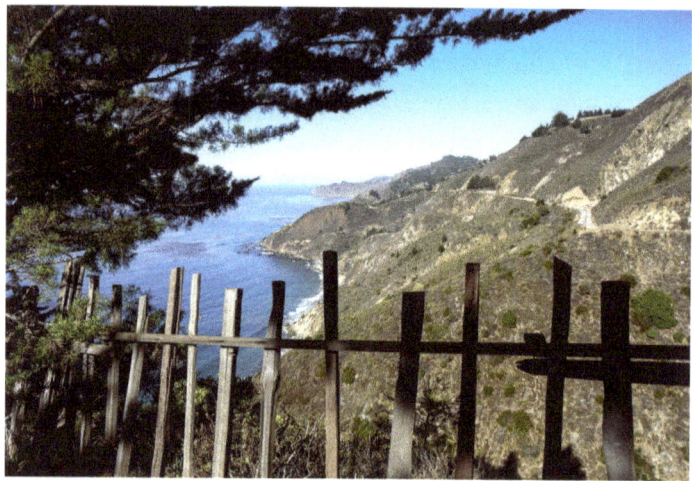

» **Fence in Big Sur, frames the background**

» **The fence and tree add a layer, contrast, and depth**

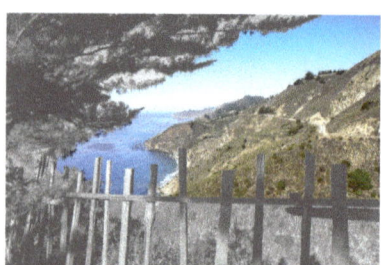

» **The frame directs your eye to the background**

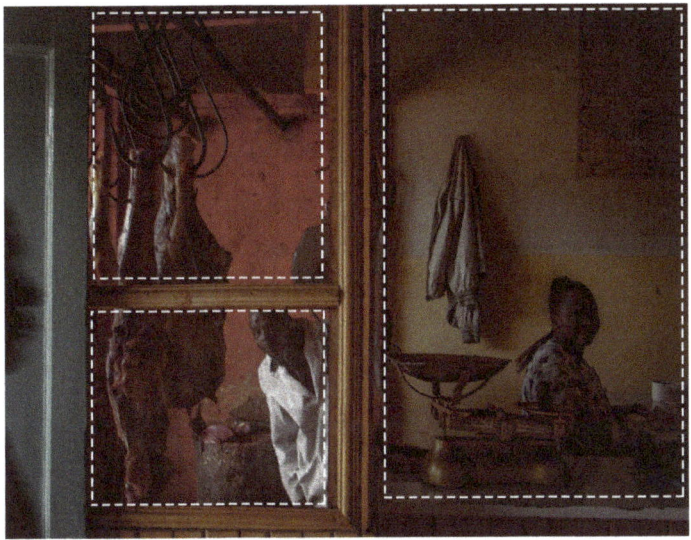

» **Multiple Frames: Butchers Shop in Eldoret, Kenya, by Robert Holmes**

There are many ways to frame your photo. The simplest is to look for trees, or a branch, walls, window frames, etc. that can form an edge around your image, as you can see in the example above; you'll see many others in the book as you read through it.

Putting an edge or frame around your composition serves many purposes: First, it highlights what you want the viewer to focus on. A frame adds order to the composition and leads your eye to the subject. It also adds depth by giving the image at least one more layer, which also adds contrast. This kind of frame adds a finished look, too. It's like you're saying, "Here is my photo—it's wrapped up and ready for you to look at!"

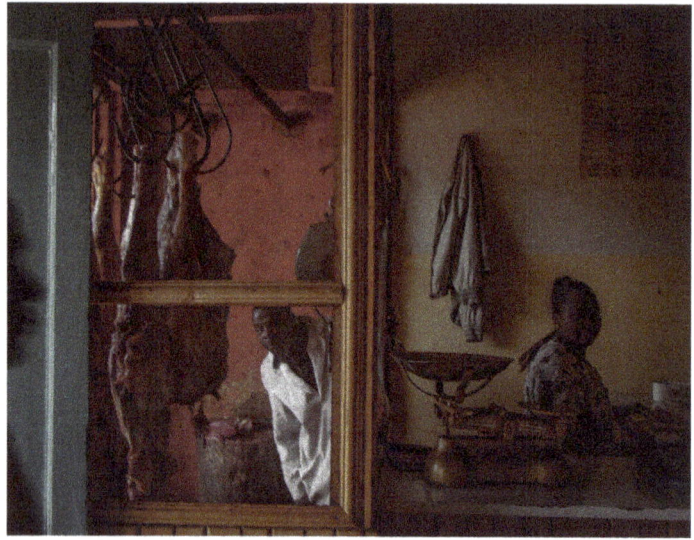

There is another definition of "framing" that means to *deliberately* place your subject within the rectangle of your camera. When you do this you are looking closely for what you want in the image and also what you don't want: for example, look at what is behind your subject—you don't want a plant or tree growing out of his or her head. Or there may be a splotch of light next to them that pulls the viewer's eye off course. In these cases, move your subject or move yourself to properly frame your subject with no such distractions.

An additional tip: less is usually more. Don't clutter your image with anything not needed to tell your story. We call this "scanning the frame." And be sure to pay attention to the edges of the frame as well.

## 2. LANDSCAPE FORMAT

Landscape format means that you compose with the long edge of your camera parallel to the ground, often used to capture natural scenes, hence it has been called "landscape."

But, even though you compose this way, it doesn't mean you have to use it just for "landscapes." Many times portraits are composed in landscape format especially when they are showing the subject's environment, which is called an "environmental portrait."

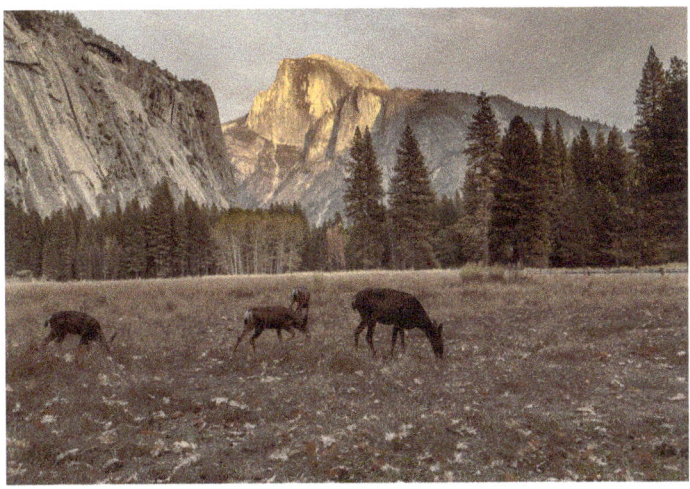

» **Classic Landscape of Half Dome, Yosemite National Park, CA**

## 3. PORTRAIT FORMAT

Here you have the long edge of your camera turned up (perpendicular to the ground). It is often associated with a portrait of a person but, again, many landscapes are taken in portrait mode. It's all up to you which format you use to tell your story, and you can always shoot it both ways and decide later which works best.

» **Portrait of a Deer, Yosemite National Park, CA**

## 4. TURN AT AN ANGLE

Sometimes to get your photo to "pop" it is as simple as just turning your camera on edge, as you can see I did here with my seventh grade classroom. I first shot it as a straight up portrait and decided it would be more interesting to shoot it on an angle, so I just turned the camera at about a 20-degree angle to get a totally different flavor of the classroom scene. But when you compose on an angle, do so purposefully to communicate what you intended, not just to have it appear as a crookedly captured image. As with most of these tools, that may take some practice.

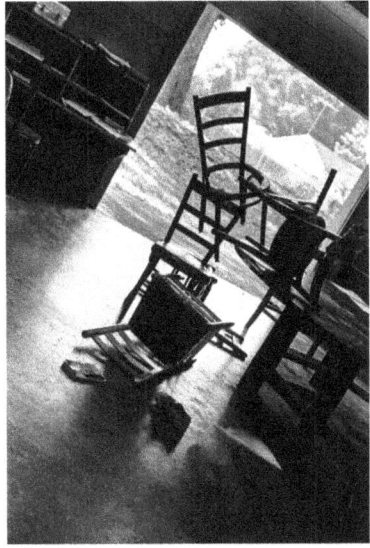

## 5. POINTS OF THIRDS: PLACE INTERESTING ELEMENTS ALONG THESE LINES

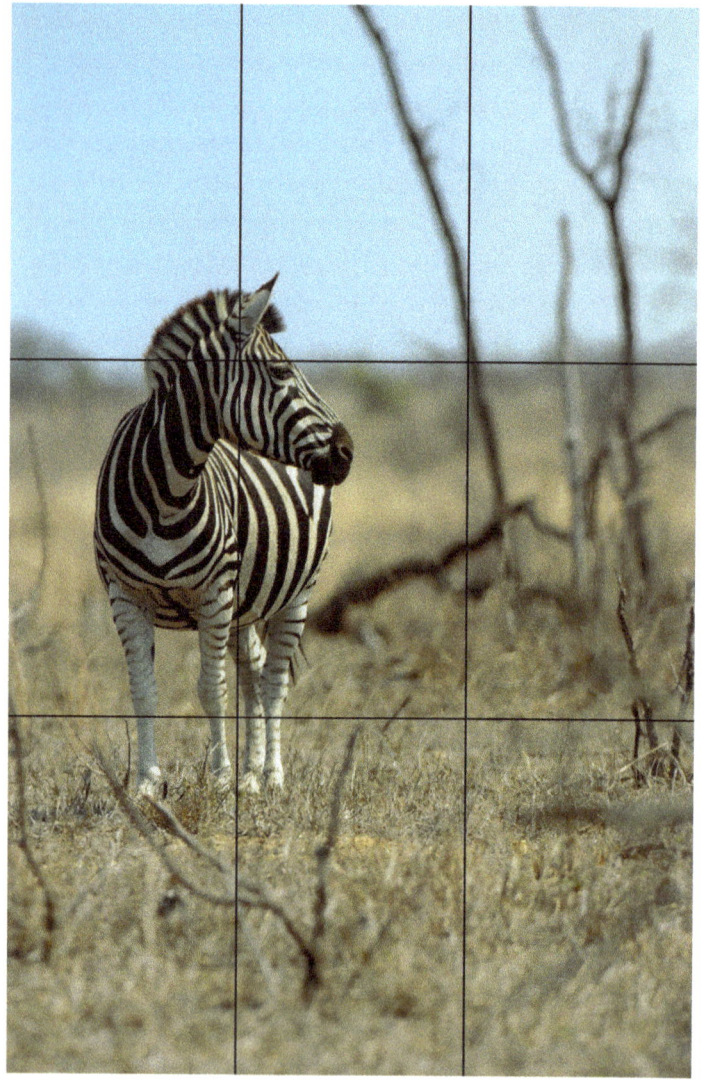

» **Kruger National Park, South Africa, by David Smith**

Back in 1797, John Thomas Smith, an English engraver, remarked that you could break an image into lines of thirds as an aid to composition. He suggested that, by placing important elements of composition on one of the lines or at the intersection of one of these lines, you could achieve a harmonious picture.

To do this, it helps to turn on the "Grid view" in your camera. You can find out how to set this up in the manual for your camera under "Grid view" and, on a smartphone, go to your camera settings and tap "Grid" to enable it.

David Smith, an award-winning outdoor photographer, gave this advice about composition:

> *"Use your grid view in your camera to place a subject on a point of thirds, which has a really strong dynamic pull to our eyes. You might have the subject looking into the frame or looking across the frame. If the subject is looking to the left, leave more space on the left for them to look into; same, of course, on the right. If the subject is looking up, put them low in the frame looking up at something."*

Try placing what you want to draw attention to on one of the lines or at the intersection of two lines, as you can see that David did with the zebra's face, which is gazing to the right in the frame. You'll notice that has a dynamic pull—your eyes are just drawn there. You'll see the same with the leopard and that he's gazing down in the frame.

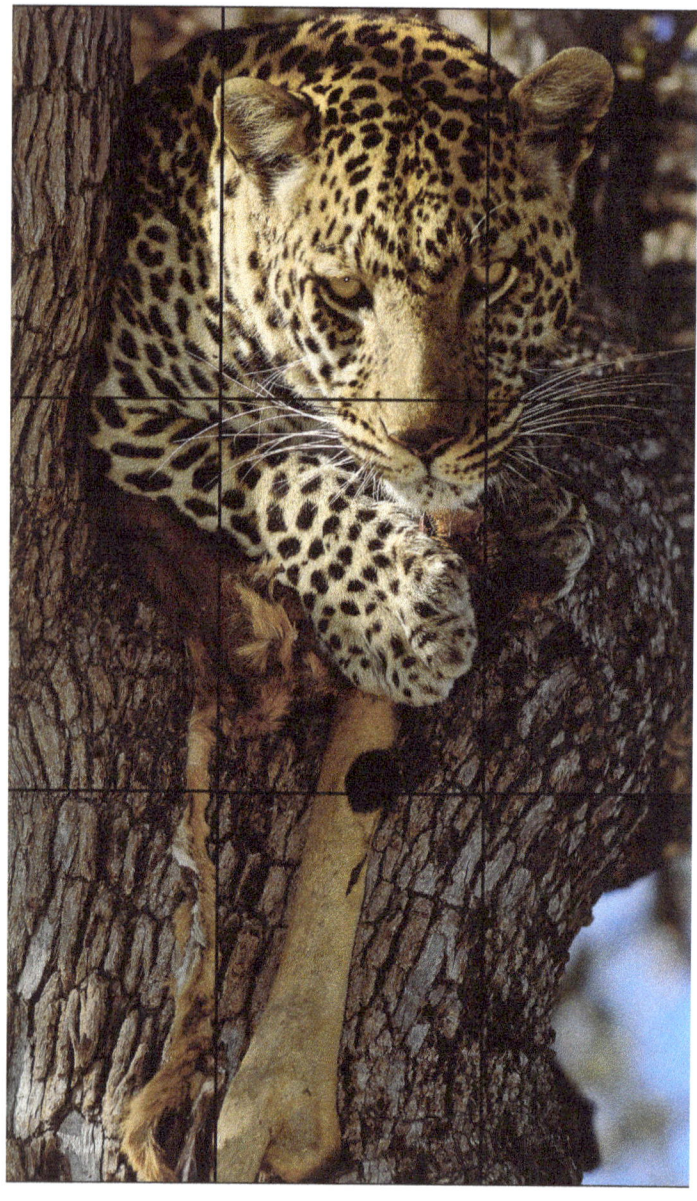

» **Leopard, Okavango Delta Botswana, by David Smith**

## 6. GEOMETRY CAN BE A PLEASURE

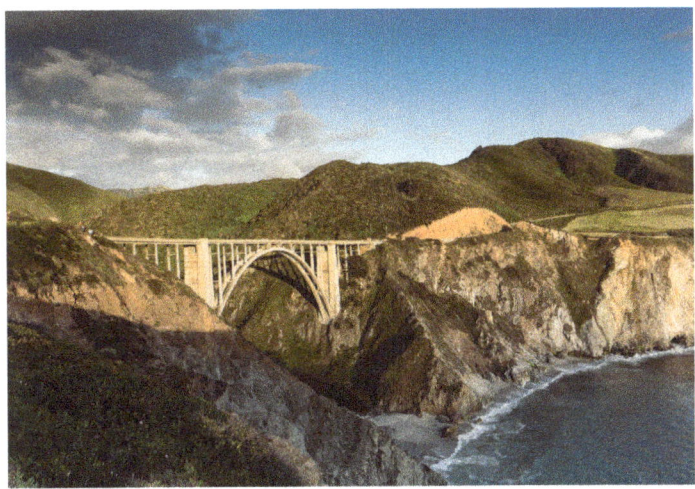

» **Bixby Creek Bridge, Big Sur, CA**

The definition of **geometric** is (a) using straight or curved lines in designs or outlines and (b) of or relating to art based on simple geometric shapes (such as straight lines, circles, or squares).[2]

There could be a misbelief that geometry and photography don't go together, that a photograph just sort of "happens" on its own with no real planned pattern.

A photograph begins with geometry since you're fitting your view of life into the rectangle or square frame of your camera. Your use of geometry in composition grows from there.

Many noted artists have deliberately employed geometry in their composition, one of the most famous being Leonardo da Vinci, who quoted Plato's inscription: "Let no one enter who is lacking

in geometry." When you look closely at da Vinci's art, you'll see he certainly wasn't lacking in geometry (see Mona Lisa, page 94).

Photographer Henri Cartier-Bresson, who was the master of photographing "the decisive moment," which is that exact instant of pressing the shutter to capture an amazing image (see #10), said this about geometry:

> *"The greatest joy for me is geometry; that means a structure [...] it is a sensuous pleasure, an intellectual pleasure, at the same time to have everything in the right place. It's a recognition of an order which is in front of you."*

Because of its integral relationship to composition, throughout this book we're going to explore the many applications of geometry in composition.

**Result:** Geometry adds a sense of structure, order and harmony, "everything in the right place."

**How to use geometry:** Develop your sense of geometry by looking for geometric shapes to photograph on their own or to combine with your subject.

## 7. LEADING LINES DIRECT ATTENTION

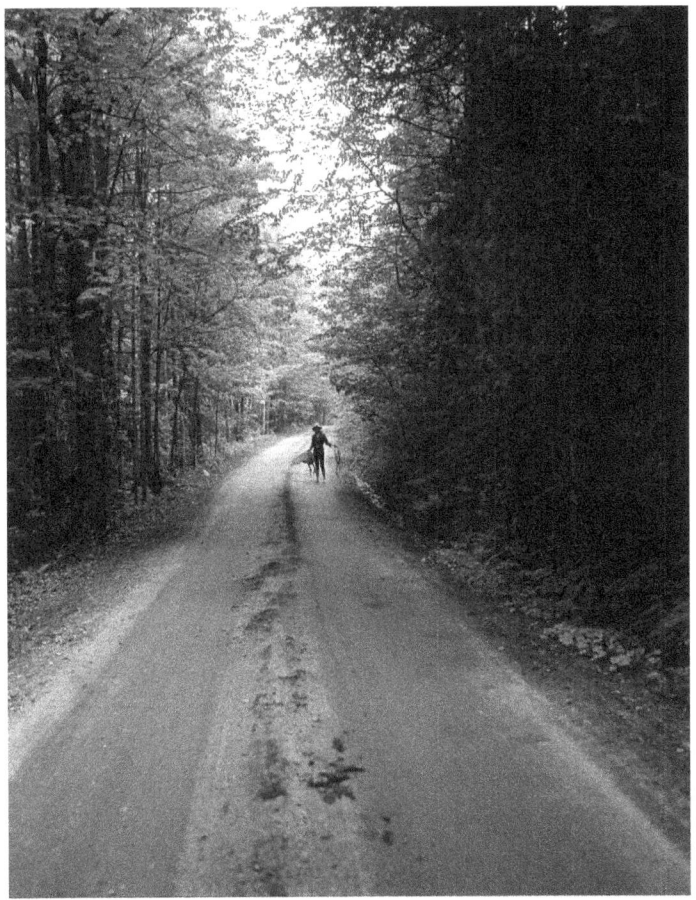

» **Walking to the Horses on Bean Pond Road, Lyndonville, Vermont**

A line is the simplest of geometric forms as it connects two or more points. You can use a line to connect the foreground to your main point of interest in your photograph.

There could be a misconception that your viewer's attention is just going to wander around, that there's no way to control it. A leading line, however, is a powerful composition tool that does exactly what is says: It leads the viewer's eye to the main subject or point of interest in your photograph. And as the lines also converge, they point even more to your subject.

It's as though you're using a pointer and saying, "Hey, follow this line … this is what I want to show you!" But it's done more subtly, of course.

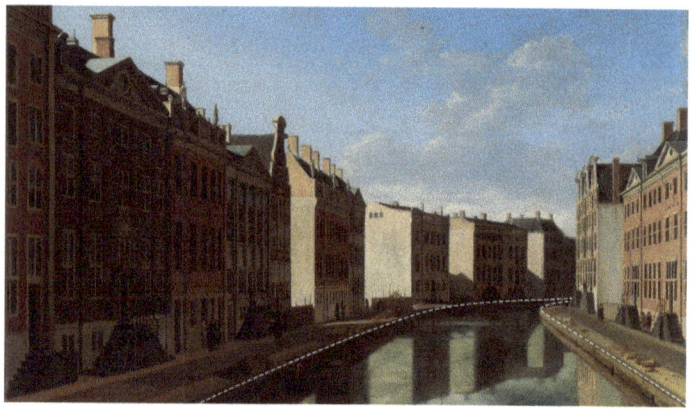

» **View of the Golden Bend in the Herengracht, Gerrit Berckheyde, 1671–1672, Courtesy of Rijksmuseum, Amsterdam**

**Result:** Leading lines direct the viewer's attention and can add the element of order, and often, depending on where the lines are, they can add symmetry, contrast, and other interesting effects.

**How to use leading lines:** Look for lines that lead off in the distance: streets, fences, and railroad tracks are good candidates. Place your subject or point of interest on a leading line as is done with the painting above.

## 8. DIAGONAL LINES CAN ADD MOVEMENT, INTEREST, AND VITALITY.

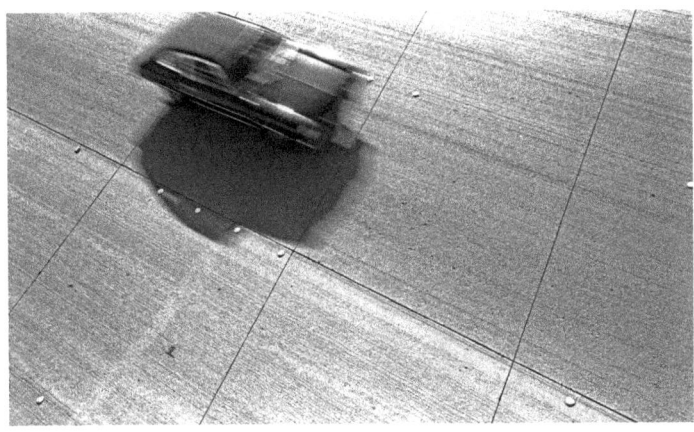

» **Car on Highway from Overpass, San Francisco, CA**

A diagonal is also a line, but it is not straight up or across, it is angled. It's amazing how effective it is in adding interest, the sense of movement, and vitality to a photograph. I captured the image above when I was in art school. I was enthralled with the work of Henri Cartier–Bresson, so consequently was constantly on the lookout for interesting geometry; the lines in the freeway also handily provided points of thirds. You can see that the diagonals add to the feeling of motion to the car passing over them.

Here's another example of what might be two tipsy chaps all dressed in their tuxedos rather awkwardly making their way across a diagonal board walkway. You can see that the diagonals help provide a sense of motion and contrast with their rounded forms.

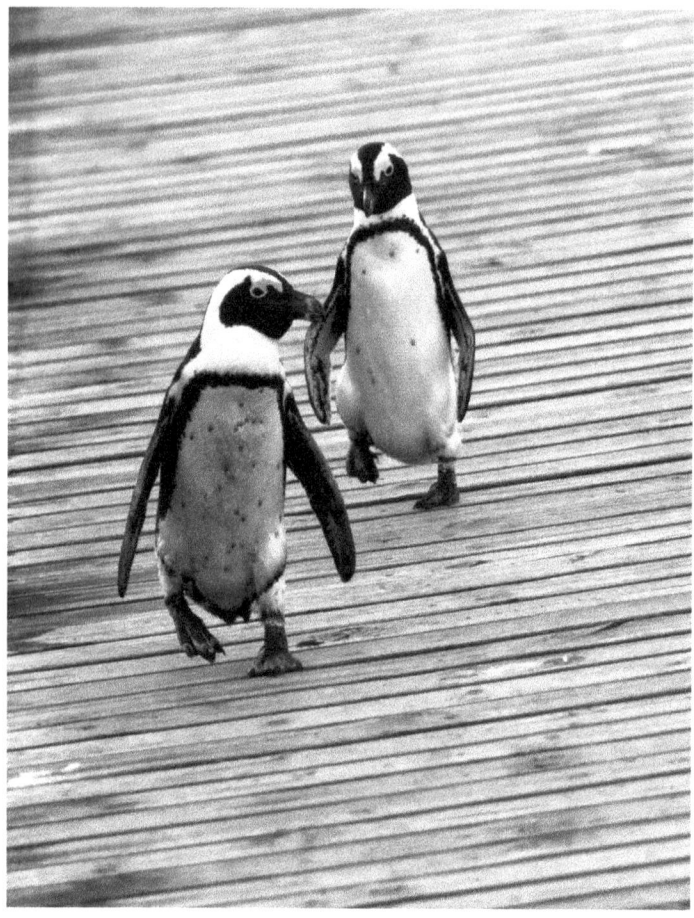

» **Penguins, South Africa**

**Result:** Diagonal lines add vitality, interest, and a sense of motion.

**How to use diagonals:** Look for diagonal lines to photograph your subjects on, shooting and experimenting with how you place them on the lines.

## 9. SYMMETRY CAN DELIGHT THE EYE

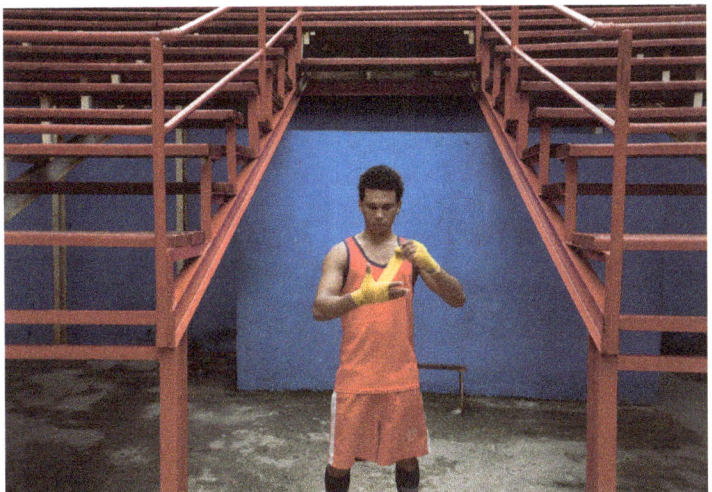

» **Boxer, Havana, Cuba, by Robert Holmes**

**Symmetry** means that you have a balance of shapes or forms around a center axis, or similar components facing each other. It comes from two Greek words meaning *with* and *measure*, so you have your forms measured or balanced with each other.

Depending on the mood you want to create, symmetry can add that feeling of balance, which can also be contrasted with an element that is not symmetrical, as with Bob Holmes' photograph above. You can see how the symmetrical bleacher frames contrast with, and draw attention to the subject.

**Result:** Order and balance that can be used on its own or in contrast with a non-symmetrical form.

**How to use symmetry:** Train your eye to spot symmetry and capture it. Look for symmetry that you can capture your subject against or move to as needed.

## 10. CAPTURING THE DECISIVE MOMENT

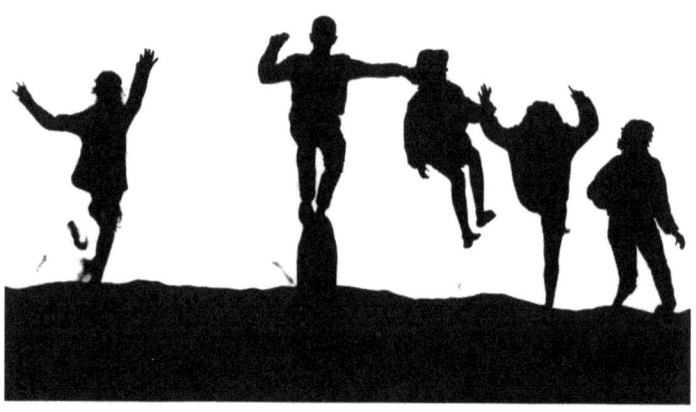

» **Friends Jumping off a Sand Dune, Morro Bay, CA**

The iconic photographer Henri Cartier-Bresson coined the phrase
"**The Decisive Moment**." In his 1952 book by the same title, he
explained what this phrase means and the process of capturing it,
underscoring the timelessness of the basics of photography:

> "Sometimes you have the feeling that here are all the makings of a
> picture—except for just one thing that seems to be missing. But what
> one thing? Perhaps someone suddenly walks into your range of view.
> You follow his progress through the viewfinder. You wait and wait,
> and then finally you press the button—and you depart with the feeling
> (though you don't know why) that you've really got something. Later,
> to substantiate this, you can take a print of this picture, trace it on the
> geometric figures which come up under analysis, and you'll observe
> that, if the shutter was released at the decisive moment, you have
> instinctively fixed a geometric pattern without which the photograph
> would have been both formless and lifeless."

The photo above is an example of such an event: the geometry of
the kids jumping was captured at the exact right moment to get

the perfect arc, with their action and gestures recorded at "the decisive moment."

A decisive moment can occur with almost any of the composition tools we're going over: it's a matter of looking for that exact moment to press the shutter. But since there is a lag between thinking about shooting, the mechanical action of putting your finger on the shutter, and the following step of the shutter actually opening and closing—to seize the exact moment—you have to anticipate when to press the button and do so before the event occurs, otherwise it will be too late.

**Result:** A moment captured with a geometric pattern that really tells a story.

**How to use "The Decisive Moment":** It requires having these elements in place:

1. Developing a sense of composition, which is the purpose of this book.
2. Knowing your camera, whether it's a smartphone or a complex DSLR. See *Advancing Your Photography*'s Chapter 3, "Get to Know Your Camera as a Close Friend."
3. Get in the "zone" and look deeply for your moment. This means being fully involved in the moment and not being half-minded or distracted, but being completely there as a photographer, seeing the action in front of you.
4. Capture it!
5. Look at your work and see if you have it.
6. Practice the above over and over until it is instinctive.

## 11. PUNCTUATION POINTS IN YOUR PHOTOGRAPHS

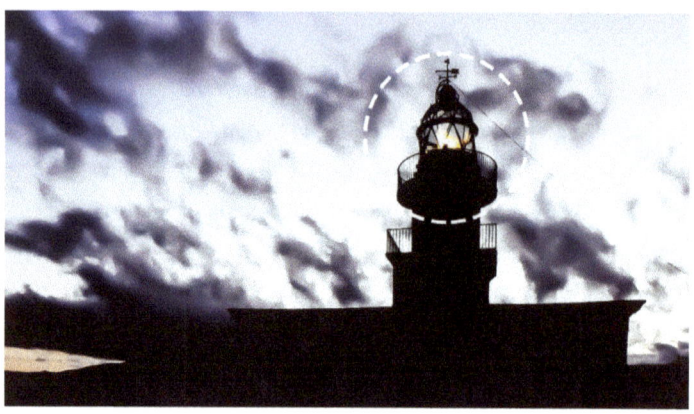

» **Lighthouse, Port Lligat, Cap de Creus, Spain**

Punctuation in writing tells the reader when to pause, stop, or really pay attention. They separate elements and clarify meaning. Photographs can also have "punctuation" points that draw your viewer's eye to the subject and add an additional note that highlights your composition. In the photo above, I captured the lighthouse in the "blue hour" after sunset and the flame of its beacon acts as the punctuation point, drawing your eye right to it.

Multi-award-winning photographer Bob Holmes explains that "punctuation really elevates a photograph, it can be a splash of color, a person, or even a dog." In other words, anything that gives it the small additional element that highlights your photograph and draws your eye to it.

**Result:** A visual note added to your photo that draws your viewer's eye to the subject.

**How to use punctuation points:** Look for them and capture them whenever you can to strengthen your composition.

## 12. CAPTURE A GESTURE AT THE "DECISIVE MOMENT"

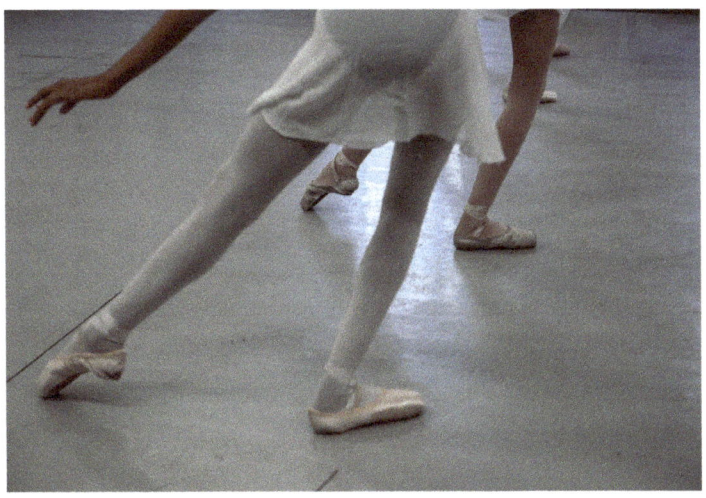

» **Ballet Dancer, Havana, Cuba, by Robert Holmes**

Bob Holmes explains that a punctuation point can also be a gesture, as seen in his photo above, that adds interest to the composition and captures action at the decisive moment. In this case, you have the dancer's toe placed at the exact moment to mirror the foreground dancer's motion, with her arm leading to it. As Holmes explains: while you're shooting, pay particular attention to the position of your subject's hands, feet, and legs to capture them at the decisive moment. A "gesture" can even be from an object—its jutting lines, for example.

**Result:** A gesture that is captured at a decisive moment that adds interest to your composition.

**How to use gestures:** Look for them and capture them whenever you can to strengthen your composition.

## 13. ANGLES ARE LIKE AN AUTHOR'S CHOICE OF WORDS

There could be a misconception that you only shoot from a standing position, and at that, from eye level only—at about five to six feet for most people. One of the fastest ways to improve your photography is to look for other angles to shoot from.

In this next section we'll look at the key angles you can shoot from, which I learned from the book *How to Shoot a Movie Story* by Arthur L. Gaskill and David A. Englander. Even though, as the title suggests, it was written for motion pictures, their points about angles totally apply to still photography.

They said, "Angles are the main ingredient of the cameraman's style. His choice of angles is as fundamental and important in his work as an author's choice of words."

I summarized the use of angles as composition tools from their book:

No-angle or flat angle. It is taken head-on to the subject or parallel or the plane of the subject. The subject looks flat, two-dimensional, not round and reduces the feel of speed.

*Part One | Fundamental Composition Guides and Tools*

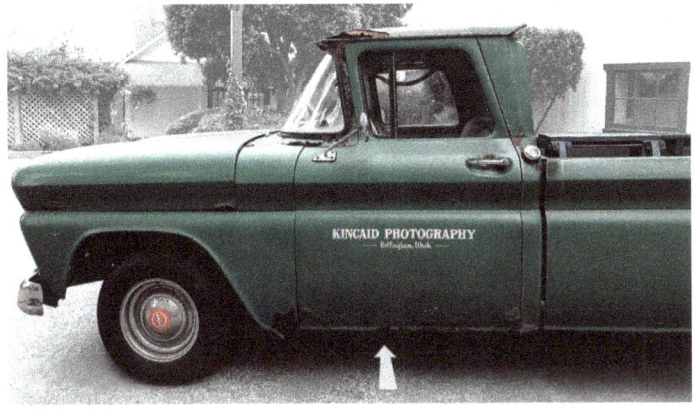

» Clint Eastwood's truck when he played a fictitious National Geographic photographer, Robert Kincaid, Eastwood's ranch, Carmel, CA; Taken at a "flat angle" it looks flat and two dimensional.

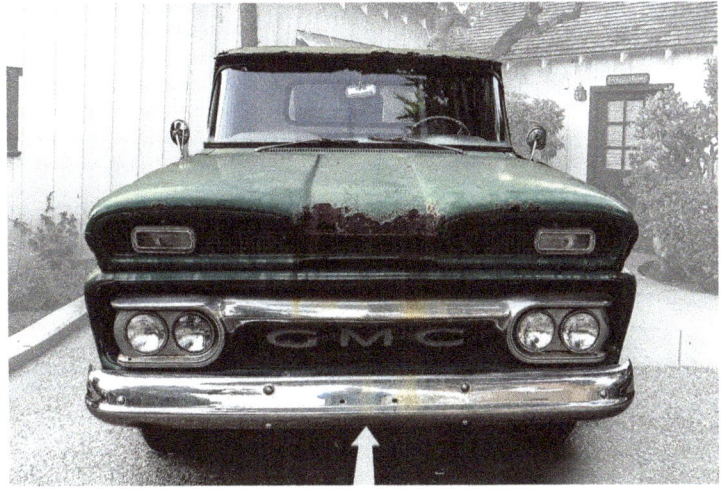

» Same when taken "head on," also a flat angle.

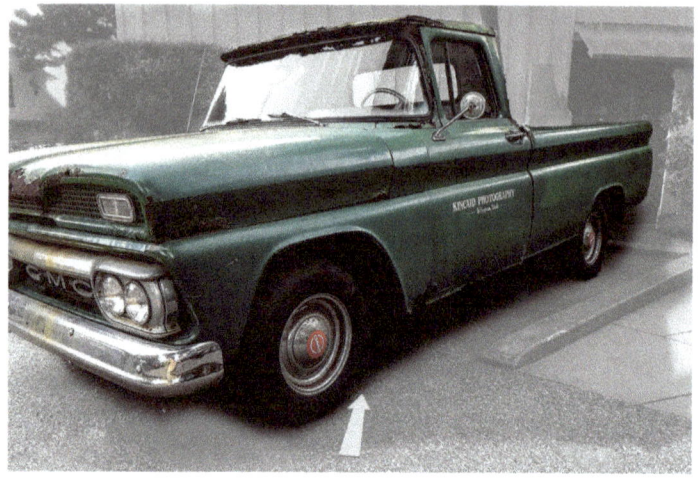

» **By moving off to the side at an oblique (slanting) angle you can see the subject now has depth and variety.**

Change your angle to emphasize what you want your viewer to see (or not see) and how you want them to see it.

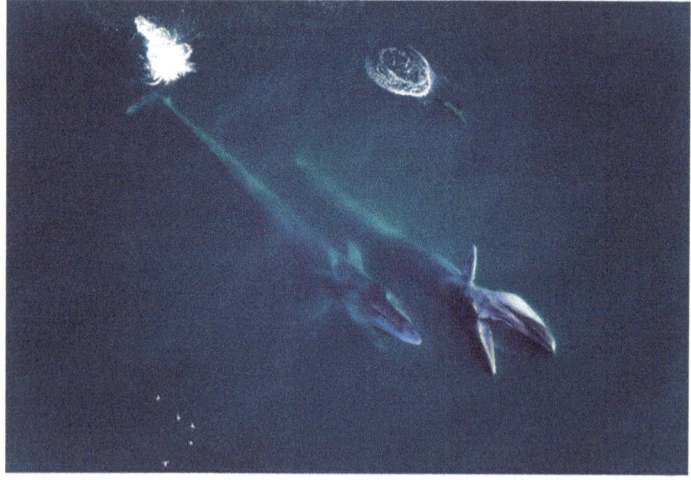

» **Fin Whales, Gulf of California, Mexico, by Florian Schulz**

A high angle shot where you are shooting down on the subject reduces the subject's height and slows down the motion. It gives superiority to the viewer over the subject.

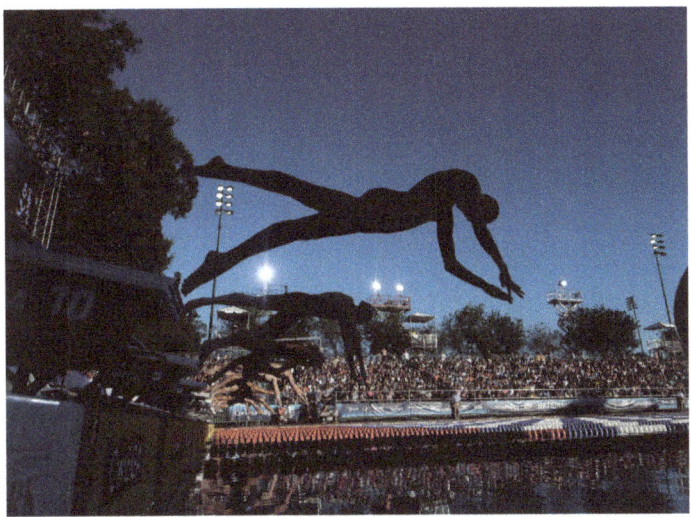

» **The Start, by JohnTodd.com**

Low angles where you are shooting up at the subject can exaggerate the height and speed of the subject when comparatively near to the camera. The subject gains stature and commands attention and gains excitement and speed.

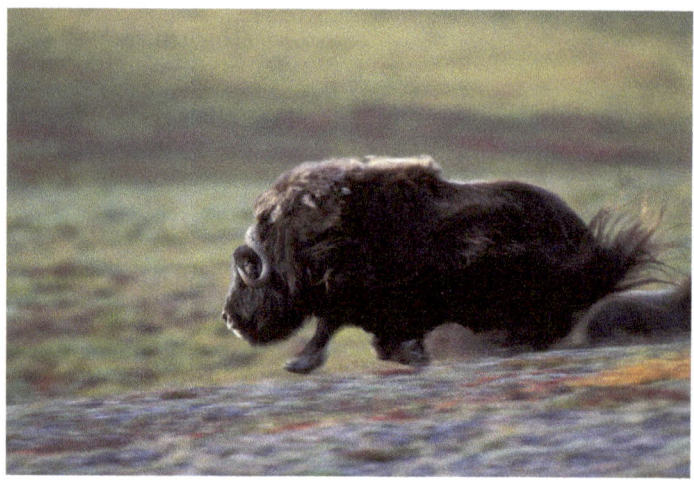

» **Musk Ox, Alaska, by Florian Schulz**

Side angle, especially the right angle, gives the feeling of increased speed.

## TIPS FOR SHOOTING WITH ANGLES:

1. Keep in mind that when you're shooting your subject from a high angle looking down on them, you will also be capturing them against their surroundings which may give you a "busy" composition. One way to clean the background up is to drop your camera angle as needed to see your subject against the sky or a wall, or other background, thus simplifying your composition (from *The Focal Encyclopedia of Photography*).[3]

Bambi Cantrell, a multi-award-winning photographer, is a master of portraiture and shared these tips with me:

2. When working with a mature woman, shoot from a higher camera angle looking down on her to avoid seeing saggy skin under her neck. This draws attention to the upper part of the face and not the jawline. Also, with any subject, have her drop her chin and look up with her eyes, which makes the eyes appear larger.
3. With a man, use a low camera angle looking up at him to make him appear more powerful, stronger, and taller.
4. When working with a heavier subject, use a higher camera angle and have them lean forward with their chest.

**Result:** Changing the angle of the shot can change its speed, and the viewer's perception of the subject.

**How to use angles:** Decide how you want to portray the subject: Shoot from a low angle to exaggerate the subject's size and speed and possibly simplify your composition. Shoot high looking down to reverse these or to improve their appearance as noted above. Shooting from a side angle adds depth and can increase speed.

## 14. VIEWPOINT: HOW YOU SEE YOUR SUBJECT

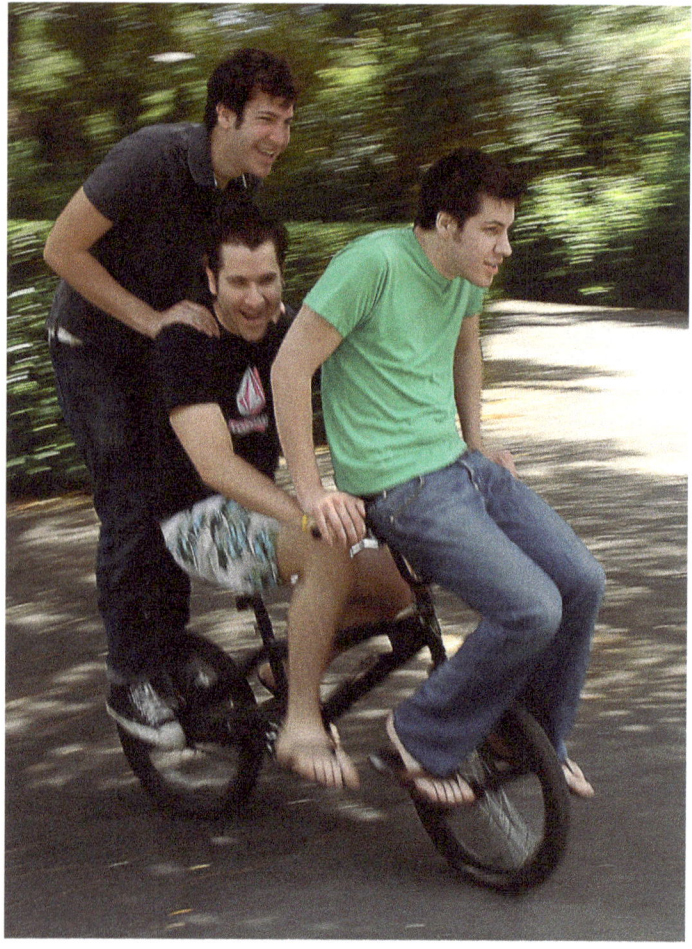

» Three of my sons making efficient use of one bike, Atherton, CA

There are several ways to vary the **viewpoint** of your subject; *The Focal Encyclopedia of Photography* explains the first of them:

> *"There are two ways in which the viewpoint may vary: in distance and in height. Both factors may be varied independently and together they form one of the most important methods of control available to the photographer."*[4]

We've covered the heights that you can shoot from resulting in the various angles. Let's have a look at distance to your subject.

As *The Focal Encyclopedia of Photography* goes on to say, the closer you are to your subject, the bigger it will be in in relation to whatever is behind it. *"This means that a particular subject appears bigger in proportion to its background as the viewpoint comes closer. So the apparent size of an object in relation to things farther away from the camera can be increased by bringing the camera closer to it."*

There are an infinite number of points of view you could assume with your camera when capturing your subject. In the photo of my boys having fun on one small bike, because I moved in close, they appear larger than the tall trees in the background. Also, instead of taking a detached and stationary viewpoint, I moved with them, letting the background blur as they would see it, to try to capture the feeling of being there with them. This is another way of expressing the viewpoint of your subject.

Another example of viewpoint is also where you stand in relation to your subject. Both of these subjects were in windows (providing excellent framing, see #1), but the top one was from an inside viewpoint, rather far away, and the other was from outside and closer up. They each have a different feel.

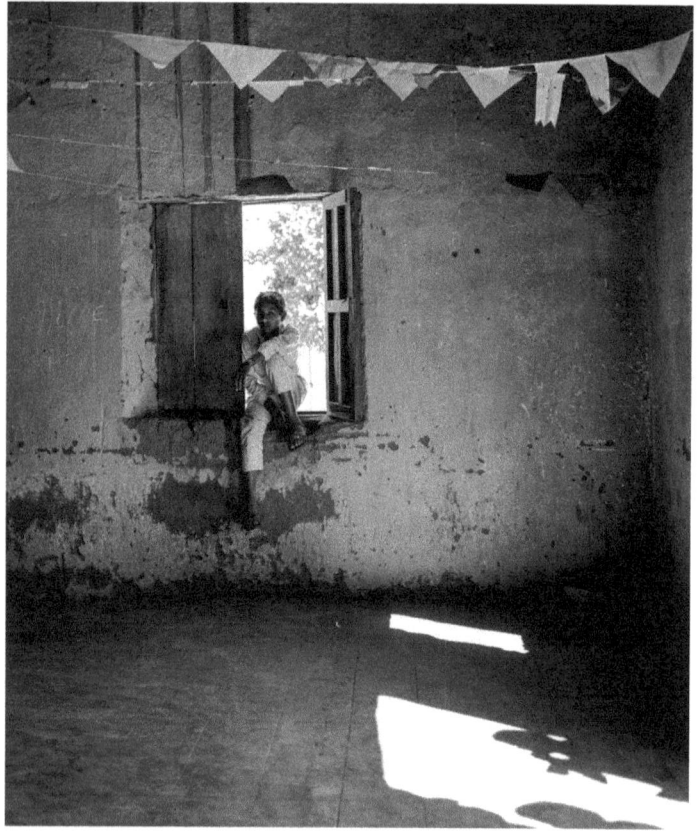

» **Boy in Window, Ajoya, Mexico**

*Part One | Fundamental Composition Guides and Tools*

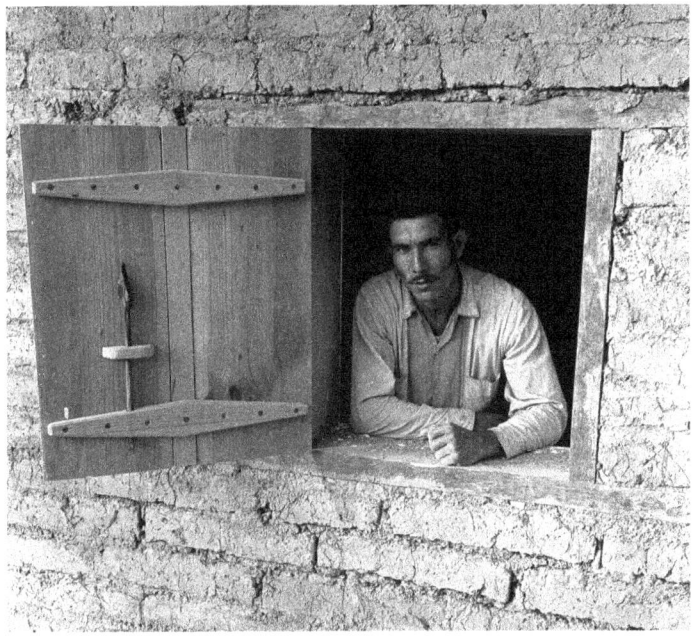

» **Fausto in Window, El Zopilote, Mexico**

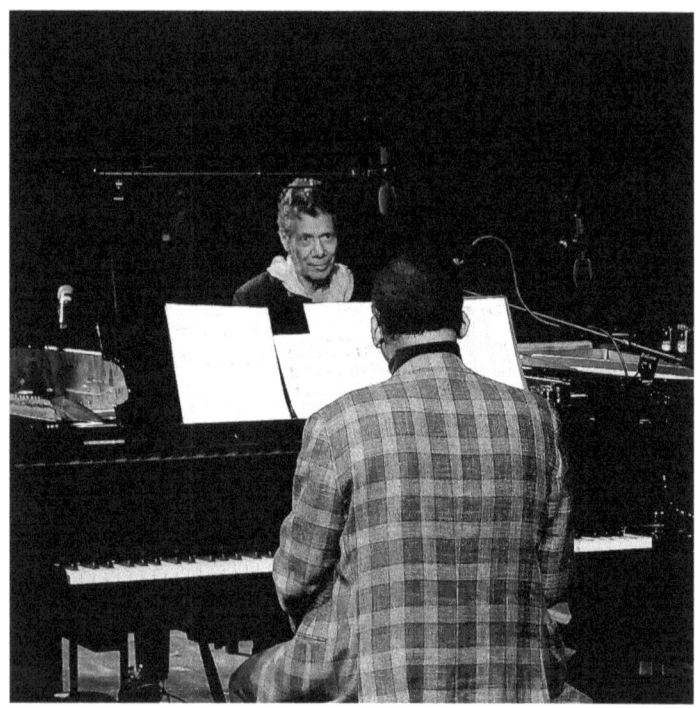

» **Chick Corea, seen from Herbie Hancock's Viewpoint, Monterey, CA**

Another example of viewpoint is shooting so that you are capturing the subject from a different point of view. An over-the-shoulder shot is one way to capture another person's point of view, as you can see in the view of Chick Corea over Herbie Hancock's shoulder: how two jazz legends see each other.

The idea is to try to look for different positions, heights, and distances from where to shoot when you are photographing. The best advice I can give you is to stay nimble and exercise your ability to shoot from different points of view and note your results.

**Result:** Changing your point of view can change the entire feel of the photograph.

**How to use viewpoint:** Experiment with shooting from different heights, distances, and points of view, then notice your results. With an action shot, you can move *with* the motion (called "panning") and let the background blur.

Next, I want to introduce you to William ("Bill") Francis Palluth (1931–2011). He was an artist, teacher, and author of many how-to books on art. When I came across one of his books *Composition Made Easy*, I was thrilled to find that he clearly defined and demonstrated sixteen composition formats for painters. Reading his book further, I saw that he based these formats upon the works of the masters. I realized that these would translate into photography, cinematography, and other visual arts. I had the idea for some time to bring his easy-to-understand and use definitions and examples of composition to photography and in the following pages you will see these.

Excerpts from Composition Made Easy by William Palluth used with permission. © Walter Foster Publishing, an imprint of The Quarto Group. At times, to keep it simple, I will simply add his initials "WFP" after each quote from him in the pages that follow for tools #15–29.

## 15. STEELYARD COMPOSITION IS BALANCED

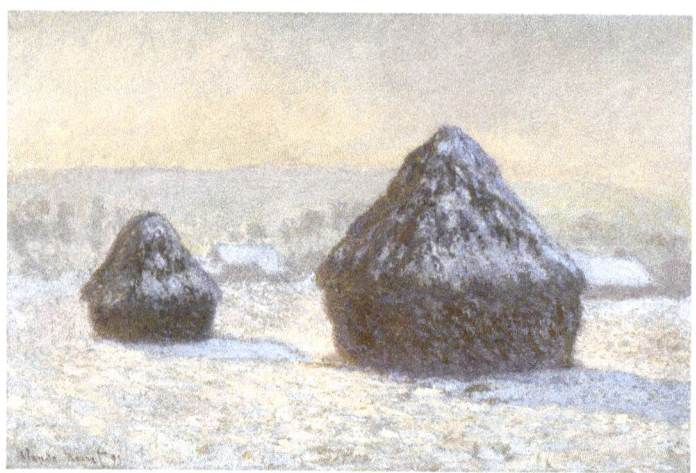

» Wheatstacks, Snow Effect, Morning, Claude Monet, 1891

The word "**steelyard**" describes a device for weighing that has a place for the item being weighed on the right side, and on the left side is a sliding weight to get it in balance, as you can see here. The larger object is on one side and the smaller on the other, as in the painting above.

"Steelyard" is a composition format that places a larger object closer to the center, balanced by a smaller object on the other side that is placed closer to the opposite edge of the picture.

This creates a feeling of balance as you can see in Monet's painting on the left.

> *"The center of interest should be close to the larger mass or may even be the larger mass itself. If the picture feels out of balance, try eliminating or moving various elements until you are satisfied. Your 'artist's intuition' will improve with experience."[5]* **—WFP**

**Result:** A feeling of balanced forms in your image and, because there are only two main subjects, there is a sense of simplicity.

**How to use a steelyard:** When you find one, capture it! Also depending on the size of the objects, you can place them and then photograph them.

## 16. "L" SHAPE COMPOSITION

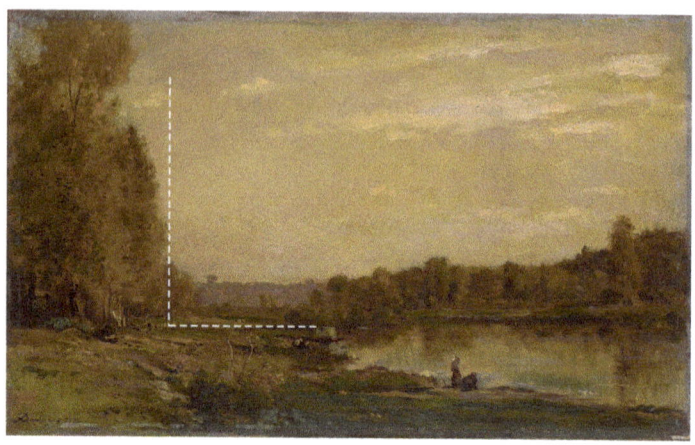

» Landscape on the Oise, Charles-François Daubigny, 1872, Courtesy Rijksmuseum, Amsterdam

Another way to lead the eye and create a sense of balance is by following an "L" shape. This is easily done with trees or other objects in the foreground, where the ground forms the bottom of the "L" and the tree or object forms the upright section. You'll see that a feeling of balance is achieved by the tree or object on one side being balanced by the open expanse on the other side.

*"In this format, a large upright mass filling one side of the picture may be balanced by just an expanse of sky or distance on the other side. If the upright mass does not quite fill its side of the picture, then a small figure or object of interest is needed on the other side to maintain balance. The 'L' Composition was a favorite of many of the old masters."*[6] —**WPF**

If you look around you'll find many examples of "L" shapes in nature, with buildings and even with how people are standing.

**Result:** Another way to create interest and balance in your photographs.

**How to use "L" shapes:** Look for them occurring naturally, such as with trees or other objects. Look for edges of buildings that form an "L" to photograph and have fun with them. When photographing people, try moving them near the "L" by, for example, standing next to a tree.

## 17. GROUPED SHAPE COMPOSITION

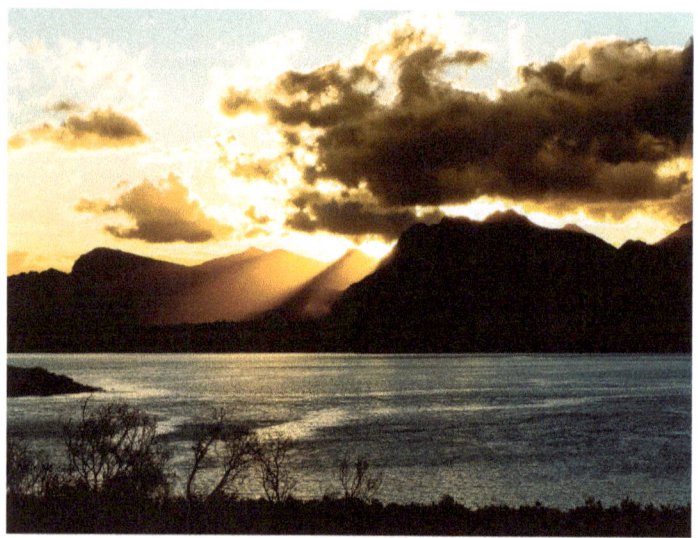

» **Hermanus, southeast of Cape Town, South Africa**

This photo has many grouped shapes: Overlapping Clouds

Mountains on the left, that overlap with ...

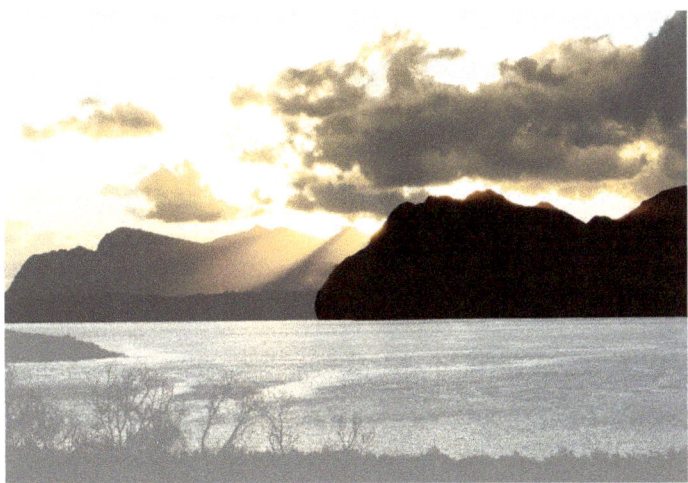

Mountains on the right, just to name three.

"Group shapes" may not sound very sexy, but it's a way to describe composition of different shapes, masses, or objects that are grouped together in a harmonious way with their edges overlapping. As you can see in the previous photo, you can have various shapes, colors, and tones that overlap, fitting together in an attractive way.

*"An important principle of pictorial design is that of overlapping lines and areas. The main outline of the grouping should be interesting yet relatively simple. The eye should usually enter at the bottom and leave somewhere near the top."*[7] *—WFP*

This is probably the most used landscape compositional technique: just look through books of paintings and photography and you'll see it is used often.

When I spoke with Camille Seaman, an award-winning environmental photographer, she described her process for, and view of composition:

> *"Think of everything as shapes. You're arranging the shapes in such a way to interact and to activate space, to push things forward and pull things back, to draw your eye here or guide your eye there. When you understand that, and you do it that way, composition becomes like a ballet, really it becomes choreography."*

This is very good advice for how to group masses that you're photographing: While shooting, move around until you find the angle or perspective where you have your masses lined up in a way that really conveys the feeling you're after. My advice is to capture many images until you know you have just what you're looking for.

You might be interested in the photograph on the previous page: I was traveling through South Africa with friends along the Western Cape, near Cape Town. Driving during the golden hours, I saw the clouds forming over the mountains as the sun was descending into them and yelled at my friend who was driving, "Stop!" and rushed out. In fact I was so engrossed in this scene that I came close to being mowed down by a passing car, but fortunately I'm here to tell the story. Remember to watch the cars as you line up those shapes!

**Result:** A pleasing and aesthetic arrangement of masses that are grouped together in a harmonious way.

**How to use grouped shapes:** When shooting landscapes, look for shapes that attract your eye and follow Camille's advice and move about to arrange them in an attractive way, taking photographs the whole while until you know you "have it."

## 18. THREE SPOT COMPOSITION

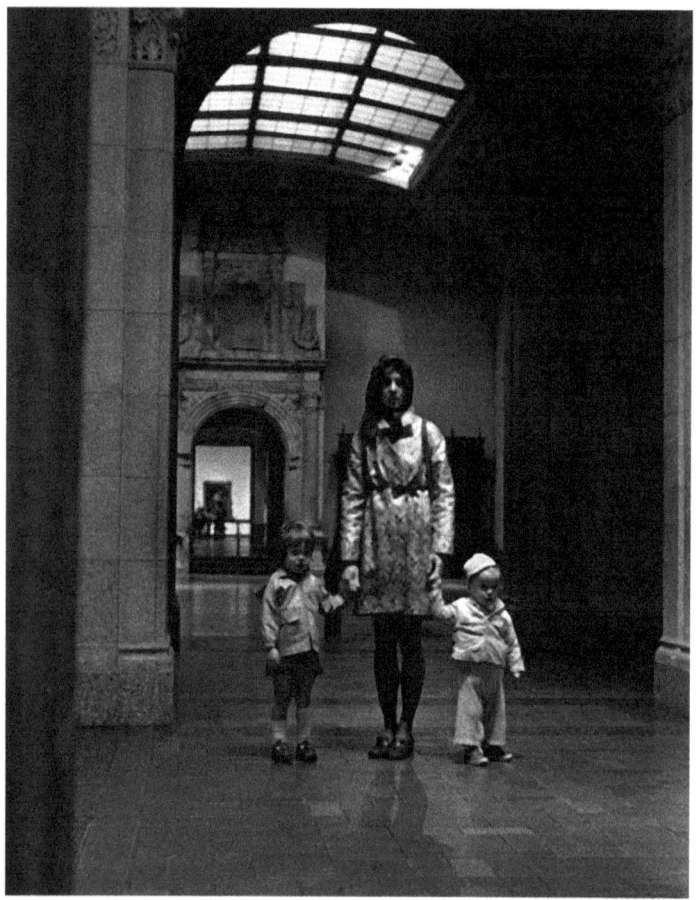

» **Woman with Her Children, Legion of Honor museum, San Francisco**

I took this photograph when I was a student at the San Francisco Art Institute; the woman saw me photographing in the museum and accommodatingly paused with her children and faced me.

This photograph, with three fugues, serves as an example of "three spot composition," but it could be three elements of anything: three trees, rocks in the ocean, or people, as above.

It's called "three spot" composition, but it really means a minimum of three points to attract the eye (two goes back to Steelyard) whereas three or more create a feeling of unity in the composition.

Williman Palluth explained it this way: "The eye automatically seeks out the most prominent objects or points of attraction in a picture, often jumping from one to another like stepping stones into the scene. If they are quite far apart, they may need to be loosely connected by a line or attraction such as a road or a path, or maybe a few fence posts to gently lead the eye."

**Result:** A connected feeling for the viewer's eye.

**How to use three spot:** Look for opportunities to capture three or more points in your photograph, looking from different perspectives; if they are far apart, see if there is a line such as road or fence to connect them.

## 19. SILHOUETTE COMPOSITION

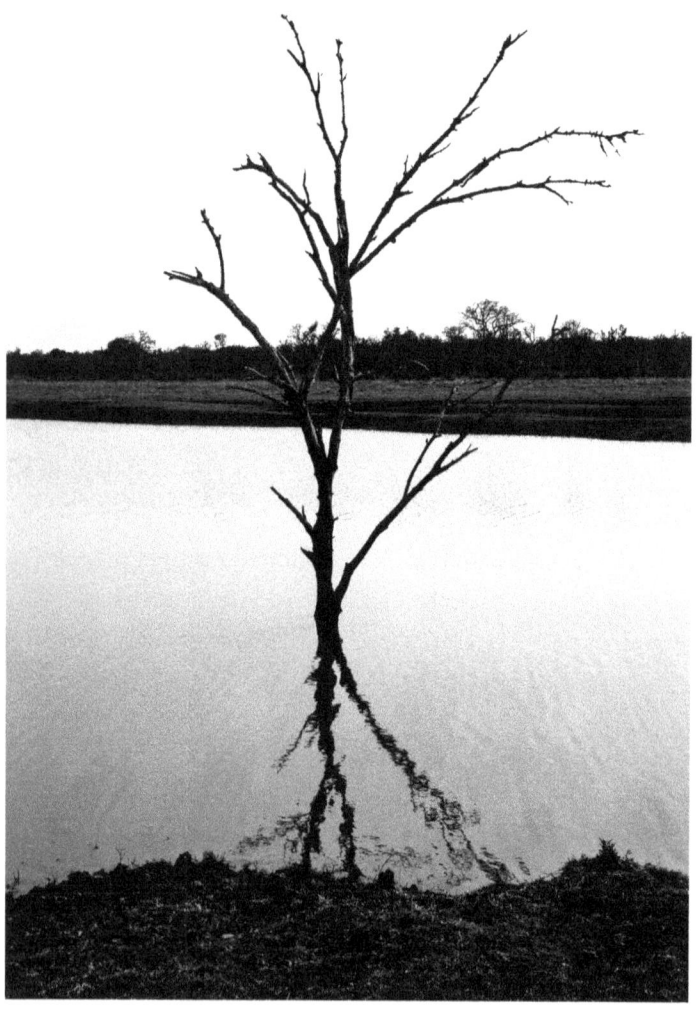

» **Dead Tree Reflected in Lake, Kruger National Park, South Africa**

A **silhouette** is a dark shape of a person or object against a brighter background. You might on occasion, find a reverse with a light shape against a dark background. It is usually combined with one of the other compositional forms we're going over.

They were also widely used in portraiture in the seventeenth and eighteenth centuries as a sort of a stepping stone to photography, as you can see an almost photographic outline of the subject. This is another example of the heritage of tools that photographers have inherited from other art forms.

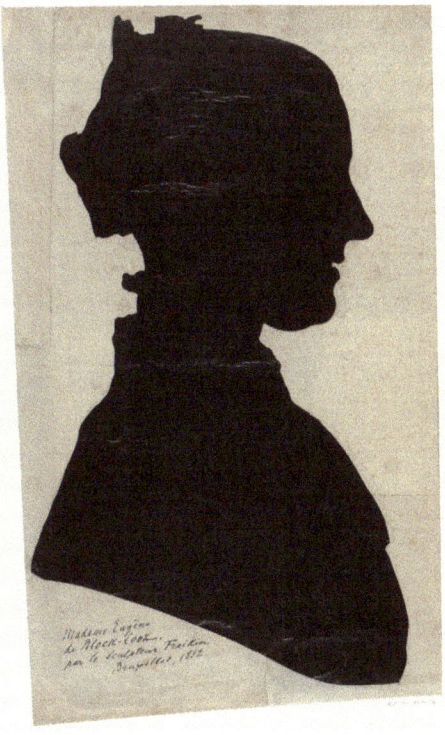

>> **Silhouette by Charles Auguste Fraikin, 1852, Courtesy Rijksmuseum, Amsterdam**

Silhouettes can be very dramatic and interesting, providing high contrast and often a simple outline of form.

My classic silhouette is the picture of my friends jumping on page 46. When I first printed it, you could see the details of the kids. It was okay, but really didn't pop until I realized I could go pure black and white, which transformed the composition entirely and gave it the spark it needed to jump out of the frame.

**Result:** An often dramatic result that combines with other compositional forms.

**How to use silhouettes:** Look for scenes or people that are lit from the back and take advantage of that to capture the silhouette. You can also pose your subject with the light or sun behind them for some interesting results.

*Part One | Fundamental Composition Guides and Tools*

## 20. TUNNEL COMPOSITION

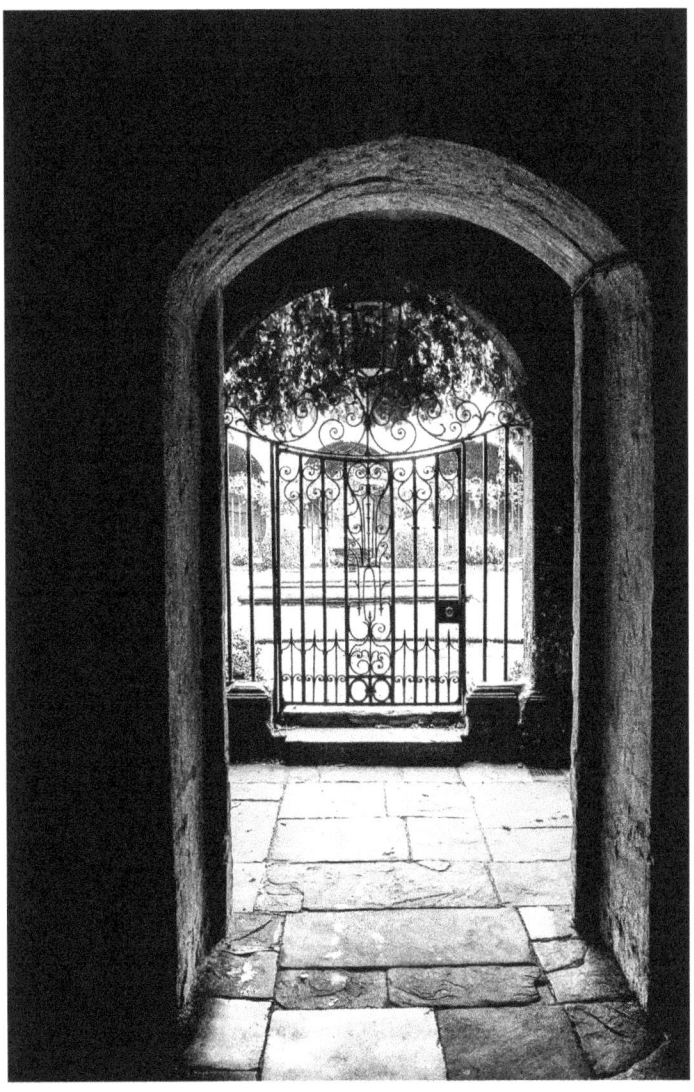

» **Westminster Abby, London**

Tunnel composition can be powerful and dramatic as it leads the viewer's eye from the foreground to the background center of interest (the point you want to emphasize in your image).

Tunnel composition increases the feeling of depth and dimension by adding layers to the foreground that separates and frames the background. It is, in fact, a dramatic way of framing your subject (see #1).

**Result:** The tunnel view adds depth and dimension and can be a powerful composition technique.

**How to use tunnel composition:** Look for tunnels occurring naturally such as trees in front of your subject, leading the eye to it. You can also place your subject at the end of a "tunnel" to highlight them.

## 21. PATTERNS CAN BE ENGAGING

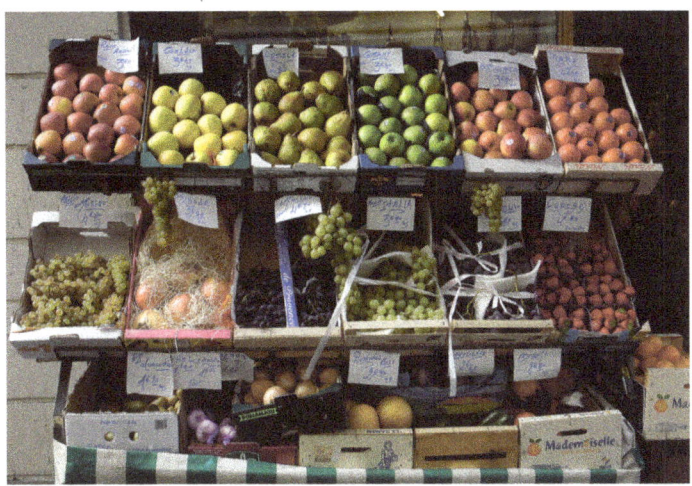

» **A pattern of fruits on display, Paris, France**

A pattern is intriguing to the eye and can be formed by repeating elements—as in the above—or arrangements of lights and darks, masses or colors, or anything that is repeated.

It's amazing how many patterns you can find all around and even though patterns might go unnoticed in our everyday life, they can have real impact in your composition.

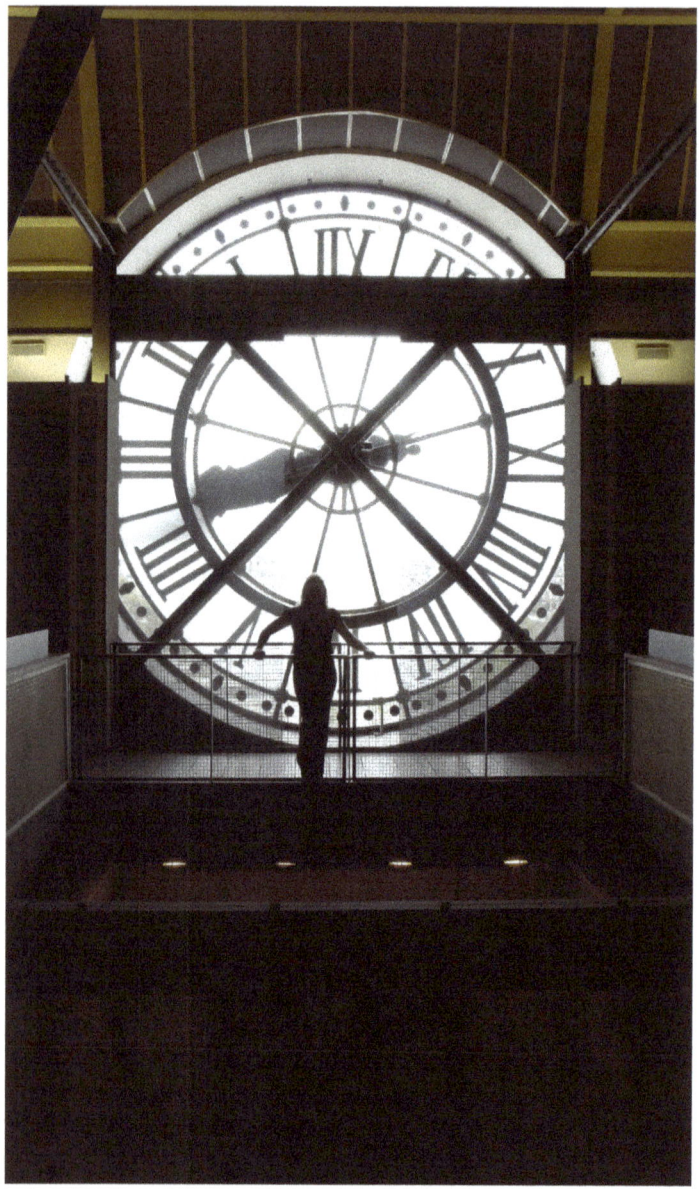

» **Pattern of the clock is interrupted by the subject, Musée d'Orsay, Paris, France**

Another very powerful composition tool is to find a pattern and then interrupt or break it, which draws attention to your subject, contrasted against the recurring elements. You can break the pattern in many ways, such as finding different colors, shapes, or placements than the pattern as you can see with the example on previous page.

**Result:** A pattern gives a sense of harmony, which can also be used to contrast with your subject by interrupting the pattern.

**How to use patterns:** Look for them in the world all around you and photograph them directly, or look for ways to interrupt or break the pattern, even moving your subject as needed.

## 22. THE GOLDEN RATIO PROPORTIONS

» Girl on Beach, Carmel, CA

The **golden ratio** appears in early written records of history, more than two thousand years ago, occurring in the treatise *The Elements* by Euclid, the ancient Greek mathematician. It is visible in the design of the Parthenon (dates back from 447 BC) and has long been used as a tool in composition. It can help guide you to create pleasing proportions and the best location for your center of interest.

Diving into the theory a bit, here's how the Britannica Concise Encyclopedia defines the golden ratio:

*"Numerical proportion considered to be an aesthetic ideal in classical design. It refers to the ratio of the base [a+b] to the height [a] of a rectangle or to the division of a line segment into two in such a way that the ratio of the shorter part [b] to the longer [a] is equal to that of the longer [a] to the whole [a+b]. It works out to about 1.618 to 1."*[8]

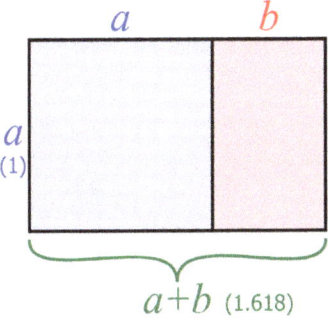

Simply put, with the math aside, the golden ratio is a proportion that is pleasing to the eye and is found in many natural occurrences in shapes of shells, plants, pinecones, and other interesting places. It's pretty amazing how nature seems to love this ratio!

Gary Meisner developed PhiMatrix software to help designers and photographers apply the golden ratio quickly and easily in composition. He told me that the most fundamental appeal of the golden ratio is that it's found in the human face—in the placement of eyes, lips, etc.

Gary said, "Here's a little secret: Compose with the same proportions others innately see as beautiful and natural."

You can take a deeper look into this by Googling "golden ratio in art" to see how da Vinci and many other artists used it extensively in their composition. You'll be in good company by learning to see and compose with golden ratios.

The first way to apply the ratio is to use gridlines similar to the point of thirds (see #5) but placed slightly differently as you can see below.

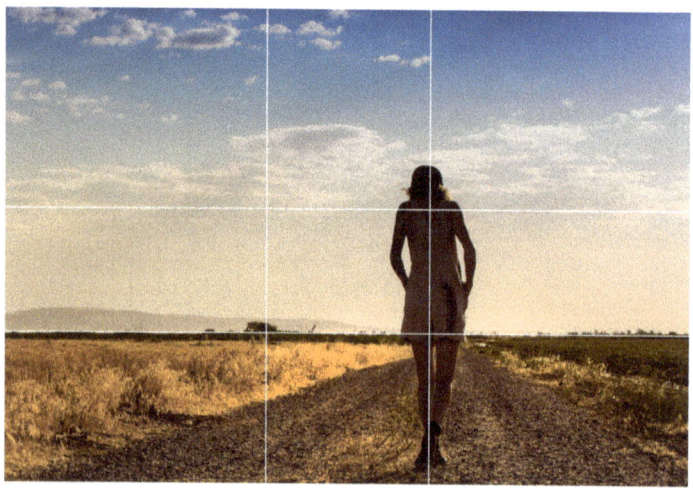

» **Layton Utah, by Jake Garn**

You can see that the grid is based on the golden ratio so it will come out with the center of interest in a different location than the points of thirds. When you use this grid for composition, try to line up the points of interest with the intersections of the lines, which are called "golden points," or on the lines of the grid. You can see in the previous photo, the horizon is lined up with the bottom horizontal line and the subject's head is placed near the golden point.

**Result:** You may find using the golden ratio grid will give you a more pleasing composition and can add it to your set of composition tools.

**How to use the golden ratio:** As with other composition tools, you need to work with it until it comes naturally for you, which follows from practice, practice, practice. There are some apps that you can try out and even a "Golden Section Finder" (go to AYPClub.com to find the resource page for these and other items mentioned in the book).

## 23. S-CURVE COMPOSITION LEADS THE EYE GRACEFULLY

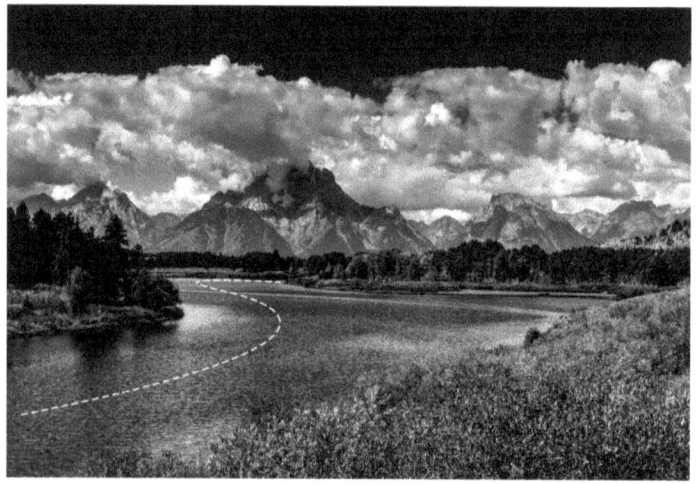

» Snake River and Teton Range, Grand Teton National Park, Wyoming

William Palluth said,

*"The 'S' Curve composition is one of the most pleasing and useful of all the compositional structures; any arrangement in which a major line, mass, or space between masses forms a gentle compound curve often resembling the letter 'S.' This format is especially useful whenever a curved road or stream is leading into the picture. Any special focal point should be along the curve well into the picture where the lines converge."*

In the photo above, the curve of the river leads your eye right to the Grand Teton, the tallest of the peaks, forming a center of interest deep into the picture. An S-Curve is a dynamic

composition format that leads your eye gracefully and gives dimension to the image and thus adds the perception of space to a two dimensional image. There is a feeling that the whole image seems to be leading away from you, since the curve goes from left to right; when the curve is reversed, moving from the upper right to lower left, it would feel as though it's moving towards you. Check it out for yourself.

**Result:** A feeling of space and motion, leading the eye toward the focal point of the image.

**How to use S-Curves:** Look for them in roads, rivers, fences, or any curved lines, and place your main focal point where the lines converge.

## 24. CIRCULAR OR "O" COMPOSITION INVITES THE EYE TO STAY WITHIN IT

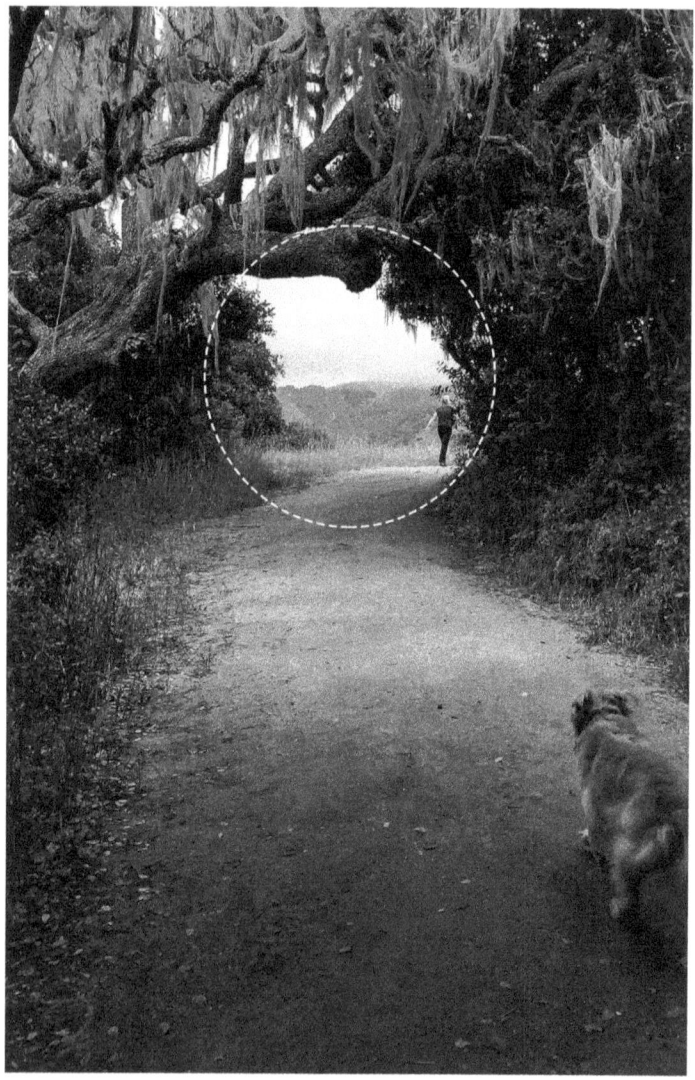

» Garland Ranch, Carmel Valley, CA

*"Circular Composition: the second most popular [after the Steelyard, see #15] form of composition is the circular format, in which the eye is caused to travel primarily in the central area of the picture. Everyone has an urge to see through an opening or through a window, and the eye is drawn irresistibly to the opening. Accordingly, the center of interest should be within the opening or somewhere along the edge. The circle is one of the easiest ways through which the elements of a picture may be unified, and many of the world's great artists used it often."*[9] —**WPF**

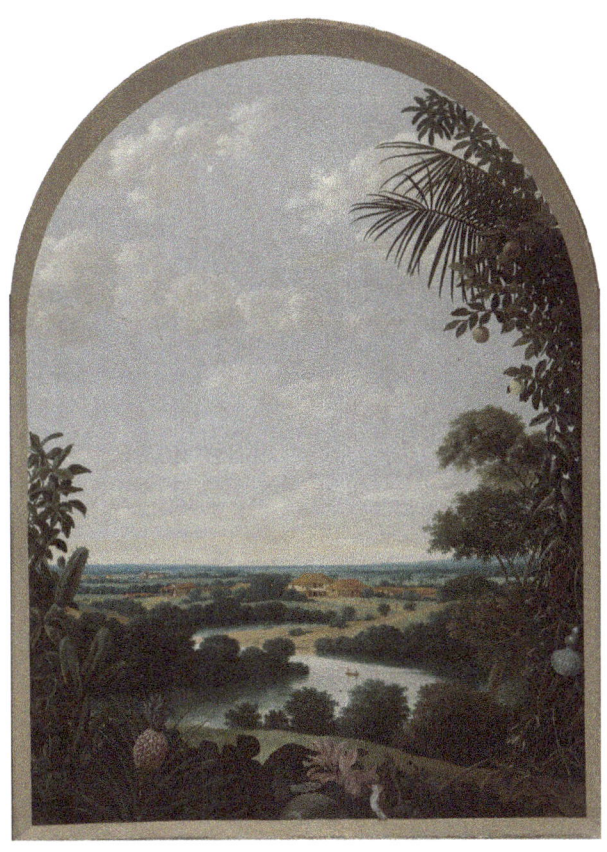

>> **Landscape in Brazil, Frans Jansz Post, 1652, Courtesy Rijksmuseum, Amsterdam**

You can view the circular opening from any angle or point of view to draw the eye into the subject. In this case, the half circular arch is completed by the horizon, and your eye is pulled to look right though it to the landscape and clouds.

**Result:** The eye is drawn to the circular opening and the central area of the picture.

**How to use "O" composition:** Look for circular openings in nature such as trees or man made items like a window on previous page. Find a center of interest near the edge or center of the opening or move your subject there.

## 25. U-COMPOSITION INVITES YOU TO LOOK WITHIN

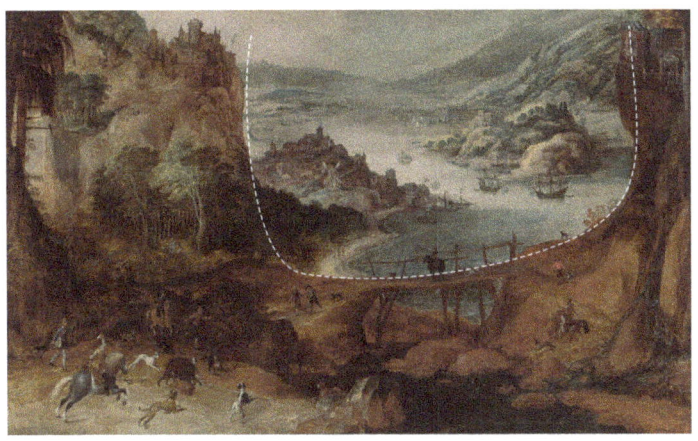

» **River Landscape with Boar Hunt, Joos de Momper (II), c. 1590–c. 1635, Courtesy Rijksmuseum, Amsterdam**

*"U-Composition is a picture with large vertical masses on each side connected by strong horizontal, usually the ground plane. This arrangement is very common in nature. The center of interest should lie either beyond the opening or along its edge, as it is with the circular format."*[10] —**WFP**

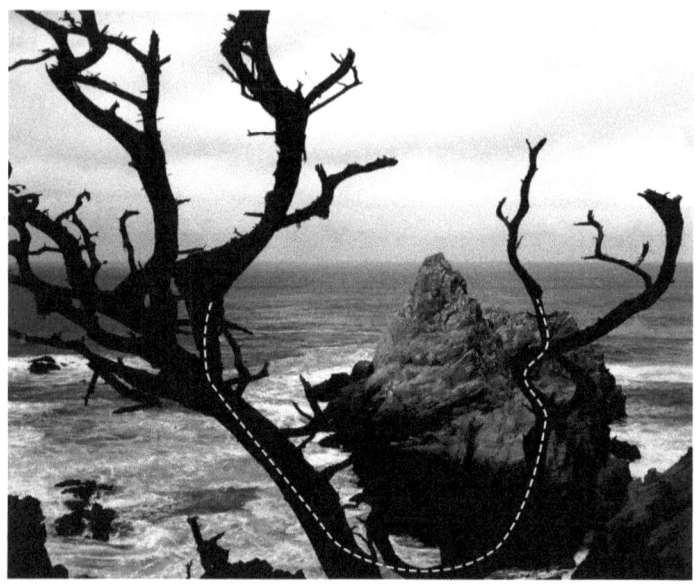

» **Tree and Rock, Point Lobos, Carmel, CA**

In this photo notice how the tree forms "a frame for the subject beyond, like curtains in a window inviting you to look between them."[11]

As with these other shapes, they don't need to be a literal or exact "U" shape to perform its function of inviting the eye to look within.

**Result:** This tool provides a natural edge to your frame that invites your eye to look within.

**How to Use U-Shape:** Look for U-shapes to form a natural frame in nature, or man-made to attract the eye within the composition.

## 26. TRIANGLE COMPOSITION PROVIDES STABILITY AND STRENGTH

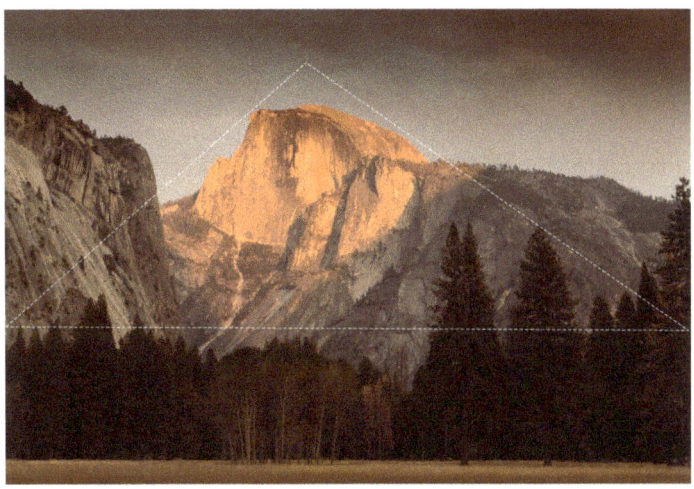

>> **Half Dome, Yosemite National Park, CA,**

*"The **Triangle** is probably the simplest of all forms of landscape composition. It may be described as any picture in which the objects are placed so that they are contained within the shape of a triangle. The triangle is symbolic of great strength and stability, and is very popular with the old masters as a means of unifying the elements of a painting. The triangle may also be used in the ground plane [see next page] as an instrument of perspective. This provides a strong pull into the picture toward the center of interest."* —**WPF**

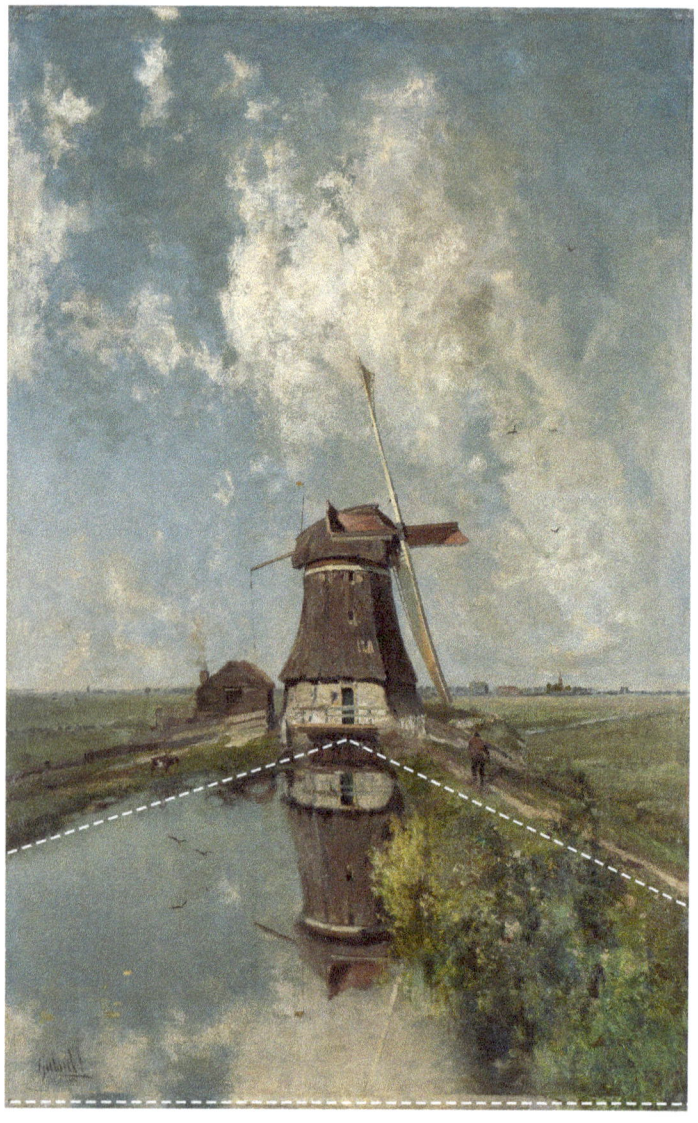

» A Windmill on a Polder Waterway, Paul Joseph Constantin Gabriël, c. 1889 Courtesy Rijksmuseum, Amsterdam

It's interesting to look at how many iconic paintings and images contain triangles within them. Rembrandt used triangles in his composition of portraits as you can see in the example below, its use extends beyond scenic landscapes.

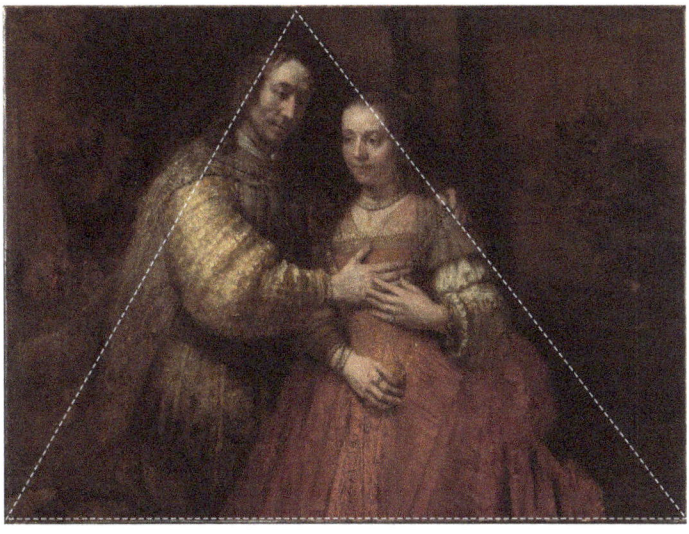

» **Portrait of a Couple, Rembrandt van Rijn, c. 1665–c. 1669 Courtesy Rijksmuseum, Amsterdam**

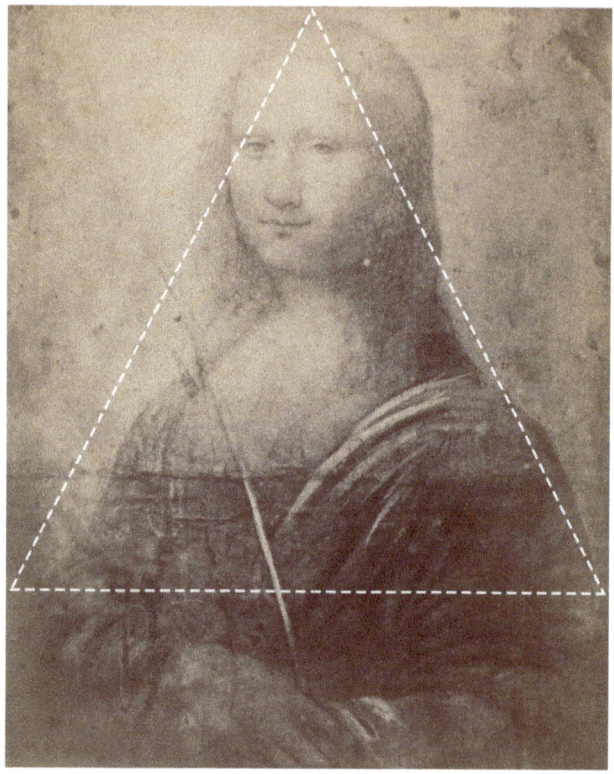

» **Photo reproduction of Mona Lisa by Leonardo da Vinci, Pompeo Pozzi, c. 1850–c. 1880, Courtesy Rijksmuseum, Amsterdam**

No doubt the most famous triangle composition is the Mona Lisa as you can see here in this early photograph.

**Result:** Use triangles in your composition to add a feeling of strength and stability.

**How to use triangles:** Look for triangles occurring naturally, or group your subjects in the form of a triangle.

## 27. RADIATING LINES LEAD TO THE CENTER OF INTEREST

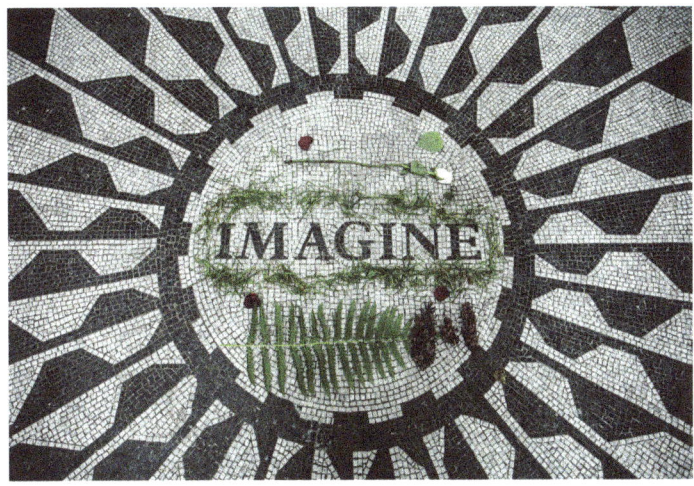

>> **Strawberry Fields, John Lennon memorial, Central Park, NYC**

Radiating lines in composition will lead the viewer's eye right to the center of interest in your image. But it doesn't need to be a complete circle as the photo above; you could have lines radiating from any point and even non-symmetrically as in my photo on the right. The effect will be the same as leading the eye to the focal point of the image.

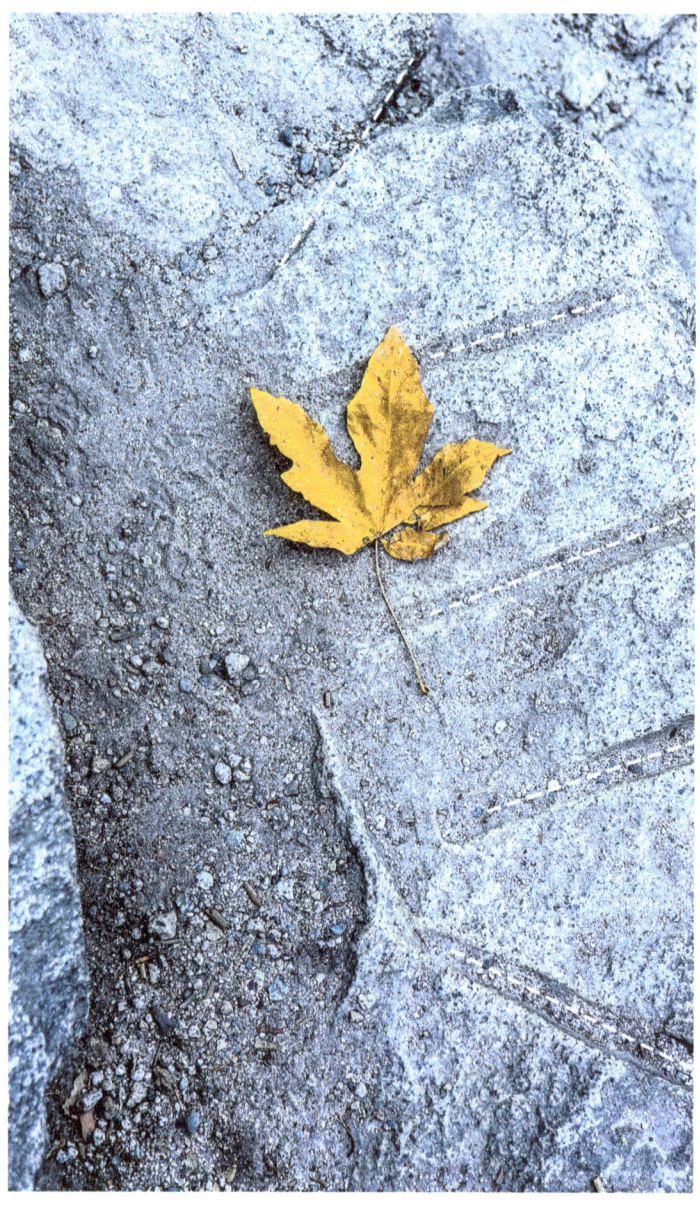

» **Leaf on Granite, Yosemite National Park**

**Result:** Radiating lines will help lead the eye where you want it to go and highlight your subject.

**How to use radiating lines:** Look for them naturally occurring or man-made and place your subject or center of interest near where the lines converge.

## 28. CROSS COMPOSITION AND EYE MOVEMENT

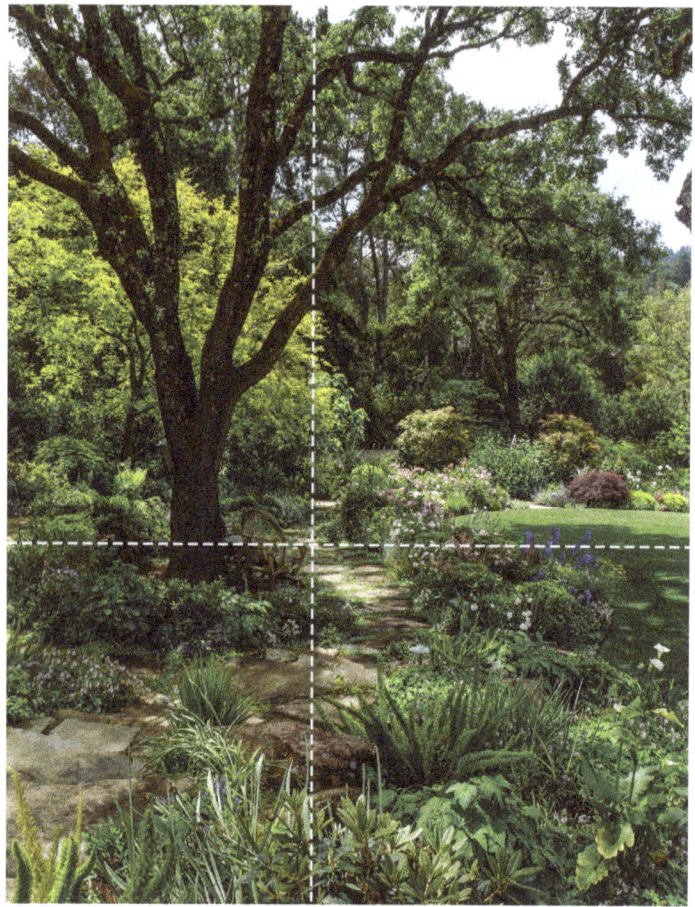

» Private Estate, Portola Valley, CA

The **cross composition** is a format where a major vertical line crosses over a major horizontal line, as in the example on the left where the path is moving vertically up the image and the tree is moving horizontally (also see example at #78).

> *"The cross composition is actually a special case of the radiating line composition. As in the radiating line format, the eye is drawn towards the intersection. Therefore the center of interest should be at that point."*—**WFP**

Let's take a moment to talk about **eye movement**: this is the path that your viewer's eye follows as they look at your image. Imagine you're walking into this gorgeous garden on the previous page ... there is an entry point of the path that directs you to the main center of attention, the tree and the chair to sit on, and then the path directs you to leave at the top. If you had gone through all the work of creating this work of art, you certainly wouldn't want visitors to wander and step all over the garden, but to follow a directed path: enter, move to the focal point, and exit.

The same should be true for your images: provide a path for your viewer to follow.

> *"Eye movement—in almost every picture there should be one main center of interest. All other elements of the picture should support that center of interest and help to draw the attention of the viewer to it. It is up to the artist to provide a directed path for the viewer's eye to follow: into the scene from the foreground, around to the center of interest, and out at the top. The viewer's eye wanders into a picture much the same as a person walks into a real scene, starting in the foreground and following the easiest path."*–WFP

The mid-line of the previous image also forms a point of balance. "The eye should be made to cross over the center line at least once in every picture and as it travels it must find something of

interest to be satisfied." In this case your eye tends to go to the upper garden in the sunlight and the maroon colored plant.

Understanding the concept of eye movement will greatly help you compose your images.

**Result:** The cross composition is another way to direct your viewer's eye to the center of interest of your image.

**How to use cross composition:** Look for examples of horizontal and vertical lines crossing and place the center of interest near the intersection of them.

## 29. BALANCE SCALE COMPOSITION

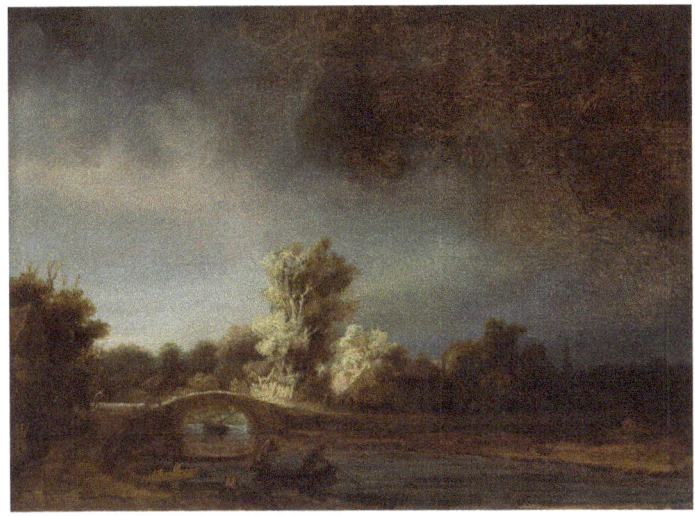

» Landscape with a Stone Bridge, Rembrandt van Rijn, c. 1638, Courtesy Rijksmuseum, Amsterdam

This painting by Rembrandt feels in balance because the main center of interest is balanced by the trees on the right and left. Also look at his use of the gloomy sky to add depth and mood, with the tree in the center lit up by the sun, inviting your attention to it. This also adds to the balanced feeling of the image.

*"The Balance Scale Composition is the classical balance so often used by old masters in their figure and still life paintings. It is a more formal arrangement with the main interest in the center and equal masses of lesser importance on each side. If there is nothing of importance in the center, a picture with divided interest will result."* —WFP

**Result**: The feeling of balance in your image.

**How to use balance scale composition:** Look for them naturally occurring such as a mountain peak balanced by two lesser peaks. You could also create a balanced composition by moving objects and/or your subject.

## 30. FIND CONTRAST IN YOUR IMAGE

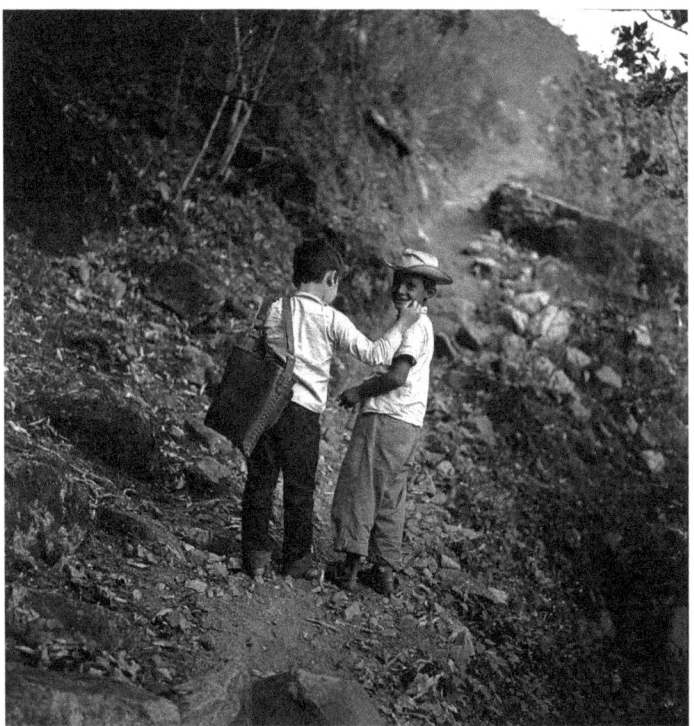

» **Boys on Trail, Sinaloa, Mexico**

Use contrast as a compositional tool to make your subject stand out against the background or foreground, or both, as in the case of the above image. Their white shirts and the hat cause your eyes to find the subjects immediately.

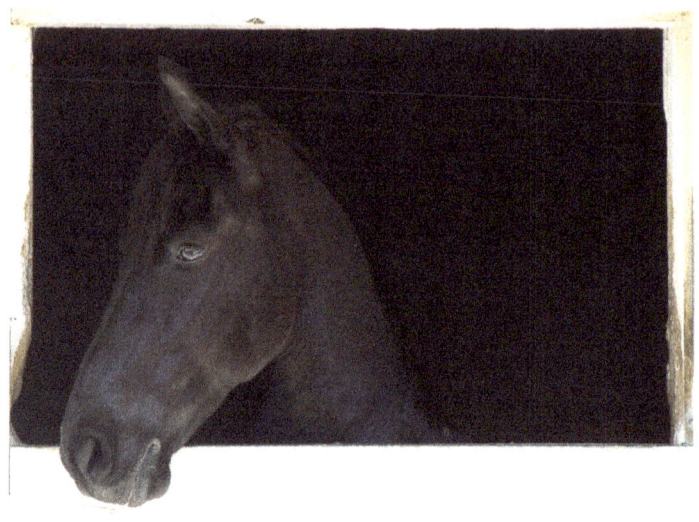

» **Horse Posing in her Stall, Atherton, CA**

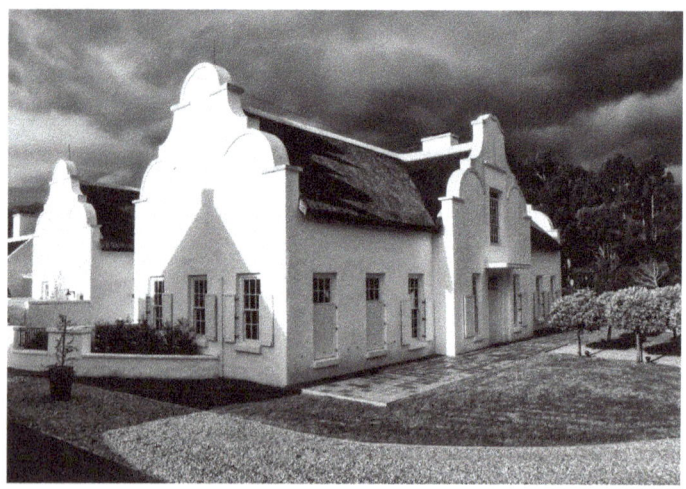

» **Chateau, Franschhoek, South Africa**

There are many ways to show contrast besides lighting, for example, the contrast between man-made and natural objects as with this image. The term for this is "**juxtaposition**," which is defined as "the fact of two things being seen or placed close together with contrasting effect."[12] Showing differences can help your viewer understand your subject and the story you're telling.

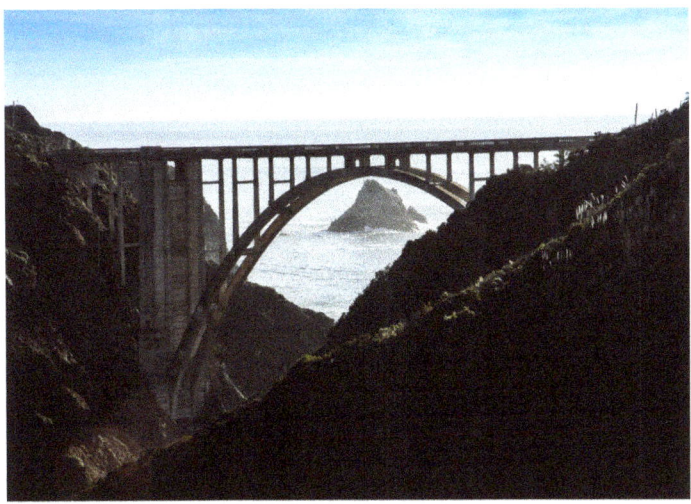

» **Bixby Creek Bridge, Big Sur, CA**

There are infinite ways to juxtapose and show contrast: old against new, man contrasted with nature, moving against still, or completely unexpected elements next to the subject, which has been used very effectively in portraiture.

**Result:** Contrast will help draw your viewer's eye to the subject of your photograph and juxtaposition helps define and highlight the character of the subject.

**How to use contrast:** Look for contrast in light between your subject and the background; or look for a juxtaposition of contrasting elements.

## 31. FILL THE FRAME BY GETTING CLOSE TO YOUR SUBJECTS

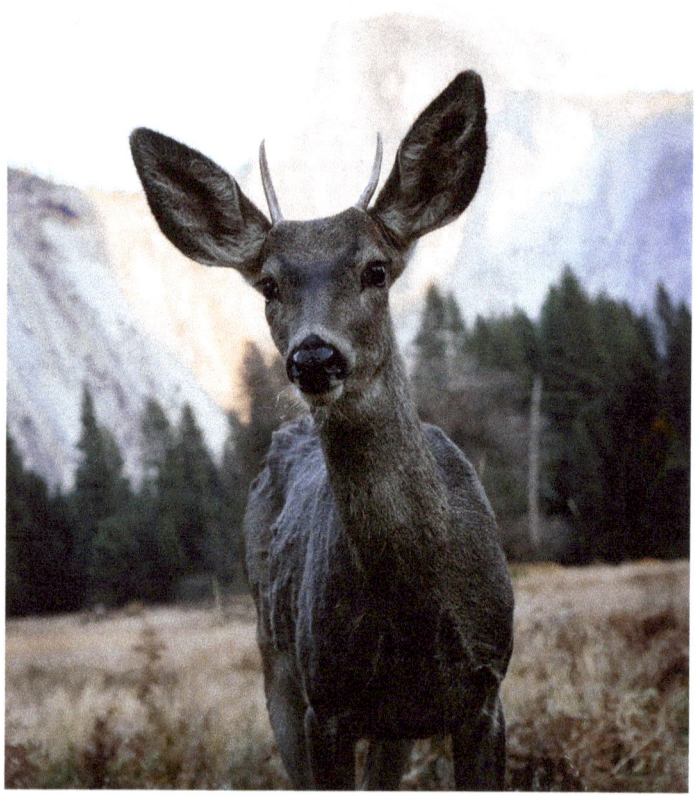

» **Mule Deer with Half Dome, Yosemite National Park, CA**

"If your photographs aren't good enough, you're not close enough," Robert Capa, documentary photographer, famously said. As he was also a war photographer, he may have also meant, you also need to get closer to the "front" of the combat. But war aside, getting closer to the "action" and your subject is always good advice.

Let your subject take center stage and fill the frame, in contrast to what we talked about with tool #11, where they might only be a small "punctuation point." The deer on the previous page in this case nearly fills the frame with his large "mule" ears, all the better to hear you with.

To fill the frame, you might have to overcome shyness about getting close to people. The best advice I can give you is to take a breath and then move a few (or more) steps closer until your subject fills the frame.

Of course, filling the frame doesn't just apply to people, you can give the majority of the image to any subject, like this:

» **Carousel, Jardin des Tuileries , Paris, France**

In this case, I not only filled the frame but also used a long exposure to show the motion, contrasted (see #30) against stillness of the trees.

**Result:** Filling the frame with your subject brings your viewer in close to, and highlights your subject.

**How to use filling the frame:** Even if you're shooting "pulled back" (see next tool), mix it up by moving in close to fill the frame with your subject.

## 32. PULL BACK TO CAPTURE THE STORY

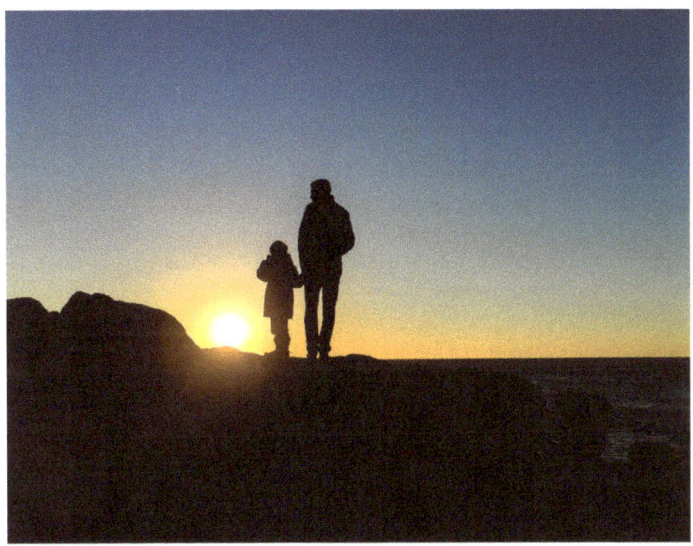

» **Dad and Son at Sunset, Carmel, CA**

The flip side to what we just talked about is to take a step back to capture the full moment of your subject. The "pull back" can be accomplished by using a wide-angle lens or simply stepping back: in either case you are capturing a wider view that takes in more of the scene and the story.

Chris Burkard is an outstanding outdoor and action photographer with huge accomplishments. He told me, "Sometimes the simple moments are the best. Whether you're out camping somewhere or you're shooting someone reading by their headlights, any simple little thing that's going to spark an interest or spark a meaning in someone, that's what I aim for."

He says it's like building a story. He always looks for those "moments in between," for example, someone getting ready when they don't know you're shooting. Look for your subject's reaction to the scene. "Pull back and see, what are they thinking, what are they experiencing?" And aim to capture that emotion. "When you stop and think about what's going to be the most significant thing, a lot of times it's not necessarily what you're seeing but what someone else might be seeing."

» **Audience at Big Sur Folk Festival, Big Sur, CA**

One of photography's versatile aspects is that you can capture a scene in many ways and later decide which tells your story the

best: you might step in to fill the frame, then pull back to get a wide shot. Compare this image to the deer in the same spot as you saw on page 106, but what a different feeling.

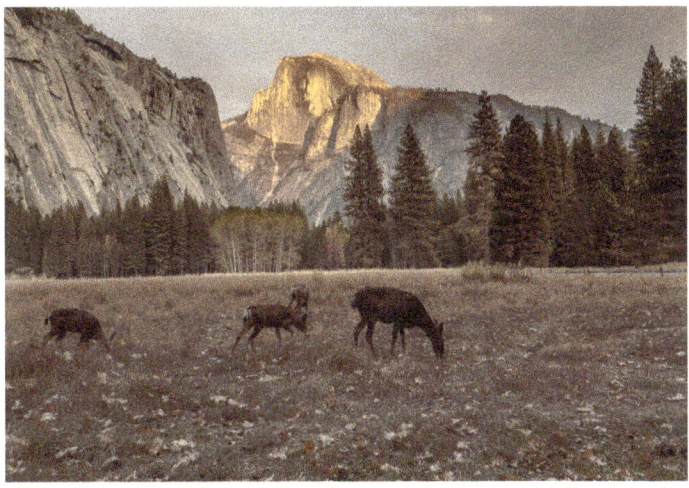

» **Deer and Half Dome, Yosemite National Park, CA**

**Result:** When you pull back, you take in not just your subject but their surroundings and often what they are seeing. This can help you tell a story.

**How to use "pull back":** You can either step back or use a wider-angle lens (even available for smartphones.) Look for options to fill the frame and/or pull back if they are available and go for it!

## 33. PLACE DOMINANT EYE IN THE CENTER OF PHOTO

» **Enjoying a Strawberry, Los Gatos, CA**

Here's a powerful tip from National Geographic photographer Steve McCurry: when you place the subject's dominant eye in the center of the frame, you'll convey the feeling that the eyes are following the viewer. Google his images and you'll see many examples of how he has used this composition technique to create a feeling that his subjects are connecting with you.

This is often coupled with filling the frame as we discussed.

This brings up another key point: We *really* connect with people when we look them right in the eye. My mother always told me—like you, I'm sure—to look her in the eye to determine the truth or fiction of one of my stories. But more than that, when we look deeply at someone and really connect, we make eye contact.

How do you determine the dominant eye? Look for the eye that seems favored by your subject or that seems to be making a stronger connection with you, as you can see with the boy above.

As a photographer, you want to be willing and able to get into close contact with others and not be afraid to move in close or step back as needed, as we've discussed. There are excellent drills that you can do to help with this, but as it's beyond the scope of the book, you can reach me on my website and I'll fill you in.

**Result:** The eyes feel like they are following the viewer, creating a strong connection to the subject.

**How to use dominant eye composition:** Frame your subject with their dominant eye in the center, move as needed to make this work.

## 34. USE COLOR AS A POWERFUL COMPOSITION TOOL

» **Church Door, Ajoya, Mexico**

Color can be a very powerful composition element that easily combines with other tools, to add depth, mood, interest and other strong qualities.

I captured the photo above in my last semester of high school while I was on a project to build a medical dispensary in a remote

region of the Sierra Madre, Mexico. Up to this point, I had only been shooting black and white photos (see pages 58,59,103). As we were about to head back to the States, the head of the project loaned me his classic Nikon F and one roll of Ektachrome film. I was naturally very alert to capturing color when I came across this deep blue door of the church.

You can see that it is combined with framing and contrast, which we've gone over. But the dominant aspect of the composition is the striking color of that door!

Colors can even elicit or suggest their own association and emotions, which you can read about in *The Technique of Lighting for Television and Motion Pictures* by Gerald Millerson* in the section on Color Association. For example, he said blue has the association of "coolness, ethereality, the infinite, significance." Ethereal here means "heavenly or spiritual"[13] which makes it a fitting color to see at the entrance of a church.

Strong colors can be added to your other composition tools, as Bob Holmes often does, and you can see an example on page 45 with the boxer.

**Result:** Colors can form the centerpiece of your composition or can be combined with other tools to express moods, association, depth, interest, and other qualities.

**How to use color in composition:** Look for strong colors that can create a dominant pull in your image. Use color to combine with any other composition tool to strengthen and enhance your visual story.

*I highly recommend Millerson's book to fully understand color and artificial lighting.

# PART TWO:

# COMPOSITION LINES THAT CONVEY MOODS IN YOUR IMAGE

**MOOD LINES CONVEY FEELINGS OR STATES OF MIND**

"WITHOUT EMOTIONAL CONTENT WE MAKE PICTURES; WITH IT, WE CREATE ART."

—GERALD BROMMER, ARTIST AND AUTHOR

## 35. ACTIVE

» **River Crossing, Wind River Range, Wyoming**

In this next section of the book we'll be looking at "mood lines" which are lines in your images that can convey a mood or feeling. As you can see in this example of the line that expresses "active" and my photo of crossing a raging river—you certainly feel the subject was active in getting across!

We touched upon this with diagonal lines conveying vitality, but there are a whole host of other line forms which can help express moods or emotions.

First, let's look at the definition of mood in the Oxford American Dictionary: "the atmosphere or pervading tone of something, especially a work of art" also "inducing or suggestive of a particular feeling or state of mind."[14]

From this, you can see that lines can help bring about a feeling or state of mind. As we look these over you'll see many examples that you'll recognize.

Photographer Rikard Rodin said, "Lines have been used by artists and designers to convey mood since the first drawings in cave walls. Through repeated use, certain patterns and lines have gained universally recognized meanings."

Relating to what we talked about earlier with the flow through the beautiful garden, I want to introduce you to our next master, John Ormsbee Simonds: He was a visionary landscape architect, one of the most influential and well-known of his time. A major aspect of his genius was that he observed how people responded to the lines of design in outdoor architecture. He moved the focus from how plants were placed to a much more important element: the human interaction response to the design. In this sense he was "composing" outdoor spaces and gardens just as we do with a camera.

John Ormsbee Simonds documented these responses as mood lines in his classic book *Landscape Architecture*. The "active" line on the left, and those that follow, with their captions, are quoted from his book, with permission from the publisher, ©McGraw Hill Education.

Mood lines can help you create a feeling that is consistent with your image, otherwise you could have a very mixed message. Imagine you're on a trip and trying to show your followers on social media how you were in action from morning to night, but your image has a strong level line (see the previous example) instead of the lightning bolt line in the example above. Your message will be mixed and diluted by having a mood line that doesn't match the story you're trying to tell.

Mood lines can help you capture what you visualized or imagined for your image (if you own a copy, you can refer to Chapter 2 in *Advancing Your Photography*, or go to AYPClub.com, resources page). But it goes the other way, too: seeing an obvious mood line can help you imagine what you want to capture.

As you study these, you'll notice that they are pairs of opposites called a "dichotomy" which means "a division or contrast between two things that are or are represented as being opposed or entirely different."[15] These definitely can be used as contrasting or juxtaposed elements which we covered in #30.

You can see that mood lines are another set of tools that you can use along with those we've already covered. Like a craftsman at his workbench, when you have all your tools easily available, you can grab the right one for the right task.

**Result:** By using mood lines in your composition you can convey the feeling or state of mind you want your image to communicate to your viewer.

**How to use mood lines:** Look for them to find inspiration and then capture that mood. You can also have a vision of your photo and then look for a line that matches that mood, often by changing your angle of view or using one of the other tools we've covered. You can also make a game out of capturing each and every one of them!

In the following section of the book, we'll go on an adventure and see where mood lines take us with our composition. The format will be a bit different: I'll show you the mood line and what it means at the top, and then below it an example, plus any additional explanation as needed.

Like any new tool, you'll need to work with these a bit to incorporate them into your composition toolkit. As you look at the examples, see how they follow the mood line presented. But don't stop there, look for your own examples and shoot them until they become comfortable for you.

As a passing note, using these mood lines and their meanings could help you direct your life where you want it to go, however, that's also beyond the scope of this book, but reach out to me if you're interested in learning more.

## 36. PASSIVE

» Lake Tahoe, CA

Compare the sense of calmness of the major flat line in this image with the previous photo of the river crossing and you'll see the effect of lines in terms of creating feelings.

## 37. STRUCTURAL, SOLID, STRONG

» **Ferry Building, San Francisco, CA, iPhone**

Let's see how the same subject can convey different moods. With the emphasis on vertical lines, you feel the structural and strong nature of the Ferry Building. But see how the mood changes with tool #41.

## 38. NONSTRUCTURAL, FLUID, SOFT

» **Grasses and Coastline, Big Sur, CA**

The flowing lines of both the coastal mountains and the grasses give a fluid and soft feeling.

## 39. STABLE

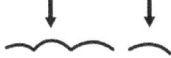

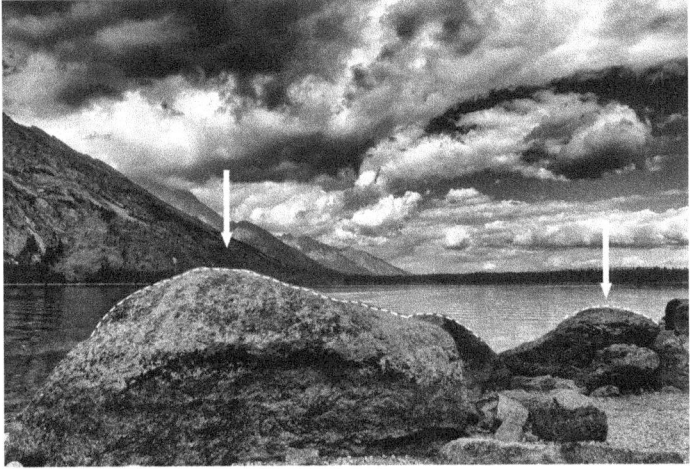

» **Boulders and Sky, Jenny Lake, Grand Tetons National Park, Wyoming**

The boulders give a feeling of stability against the downward pressure of the brooding sky (the graphic above shows down arrows meeting the stability of the curves).

## 40. UNSTABLE

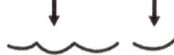

» **Surfer, Steamer Lane, Santa Cruz, CA**

Compare the feeling of instability to the previous image. In surfing, the key to a great ride is being able to master the forces of the wave that are unstable and ride it without being overwhelmed by it. You might say it's being in control in unstable conditions.

## 41. STABLE

» **Ferry Building in the "Blue Hour," San Francisco, CA , iPhone**

As you can see, the same subject can be conveyed with different moods compared, for example, to tool #39. Like words, images have a "vocabulary" where you can express the same concept in different ways. For example, to express the idea of "stable" you could say "firm," "solid," "steady," each communicating the concept in slightly different ways. The same is true with mood lines: this feeling of "stable," above, is quite different than the downward pressure and curved upward lines you saw in #39. It may have occurred to you that while going through this book you're learning the "language" of composition: each example we're going over is a new "word" in your vocabulary as a photographer.

## 42. UNSTABLE

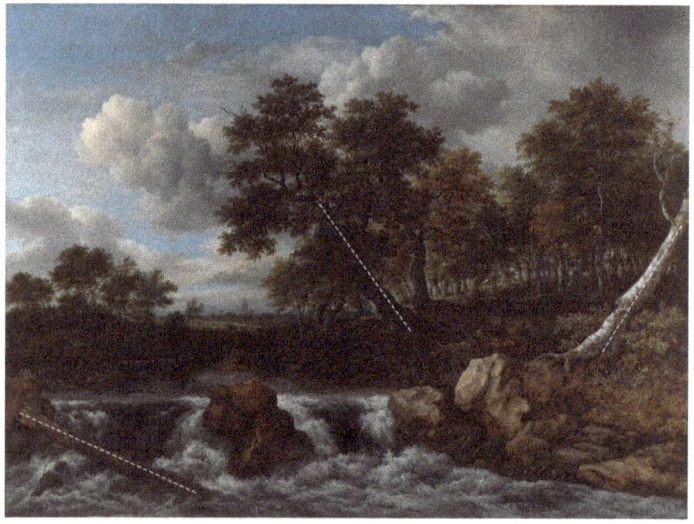

» **Landscape with Waterfall, Jacob Isaackszoon van Ruisdael, c. 1668, Courtesy Rijksmuseum, Amsterdam**

The slanting trees on the left, center, and right certainly add to the feeling of instability of the boiling river. This is a good example of the artist's use of mood lines to strengthen his composition, almost like modifiers can serve to intensify language.

## 43. POSITIVE, BOLD, FORCEFUL

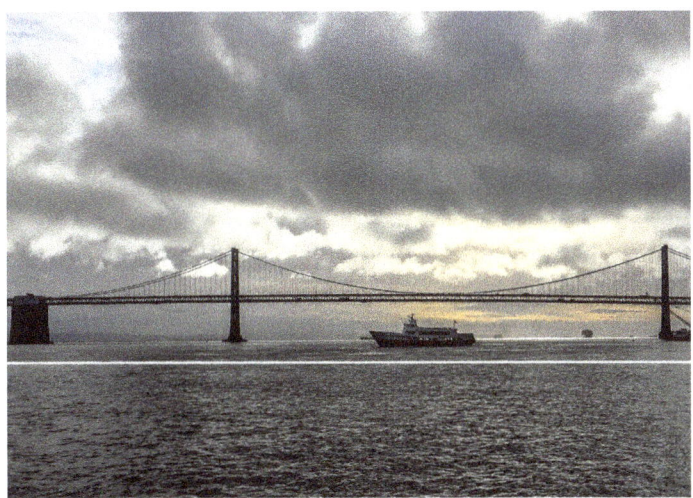

» **Bay Bridge, San Francisco, CA, iPhone**

In this tool we are using another straight line, but bolder and showing more strength. Notice that the ship in the photo also echoes its own forceful line, making way against the currents of the San Francisco Bay.

## 44. TENUOUS, UNCERTAIN, WAVERING

» Self-portrait, Vincent van Gogh, 1887, Courtesy Rijksmuseum, Amsterdam

From what we know of van Gough, he was uncertain and wavering about himself, reflected in the many tenuous mood lines in this painting. When you're telling your story with your images you want to be able to express any mood needed with the use of these tools.

# 45. THE VERTICAL— NOBLE, DRAMATIC, INSPIRATIONAL, ASPIRING

» Doorman at the Dakota Building, standing where John Lennon was shot, NYC

This mood line has at least four qualities attached to it, yet the image may only convey one or two. Again, like words that have several meanings, not all need to apply to your image. But you can create or find other images that will apply to some of the other concepts such as inspirational and aspiring.

# 46. THE HORIZONTAL— EARTHY, CALM, MUDANE, SATISFIED

» **Plants Growing Out of Rock, Teton National Park, Wyoming**

Here again, you have several meanings or moods for this flat line. Use it to express your intended mood, this one is earthy.

## 47. PRIMITIVE, SIMPLE, BOLD

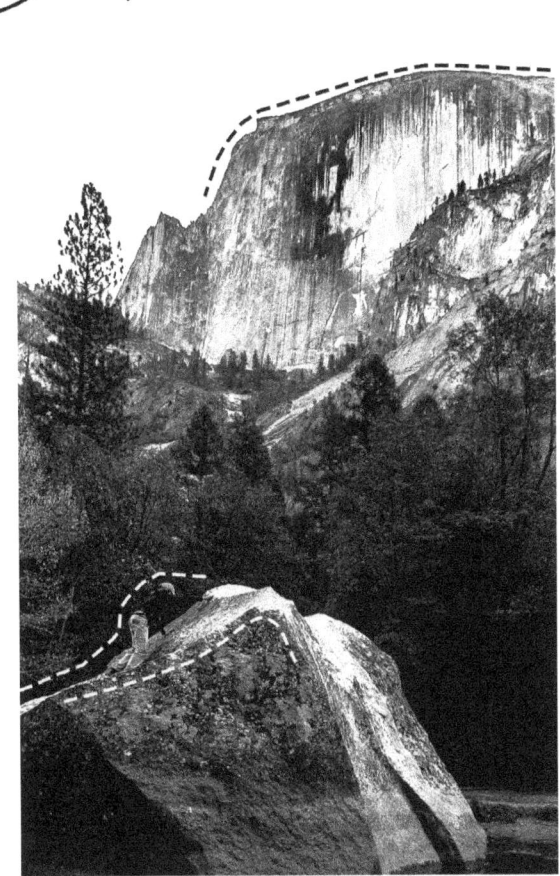

» **Boy Climbing a Boulder Below Half Dome, Yosemite National Park, CA**

Here you see three similar mood lines: the top of Half Dome, which runs in reverse to the boulder, and the boy's line paralleling it. All three express the same moods of simple and bold.

## 48. EFFUSIVE

» Jerry Garcia, by Michael Zagaris

Effusive here means full and expansive, which Garcia's hair (and music) certainly were good examples of. It could also be used to show something was unrestrained or over the top, as in an effusive greeting or hug. That's what makes the game of finding or creating mood lines so interesting—looking for different ways to express these various moods, like music or language.

## 49. FLAMBOYANT

» **Ritual Dance at a Festival in Northern Bhutan, by Robert Holmes**

Flamboyant here means a style of wavy, flame-like lines, that you can best see above in the dancer's robe and the other flowing lines that give him an almost fire like, exuberant appearance. You can totally change the feeling of someone you're photographing by having them dress in flamboyant clothes and have their hair tousled, and maybe throw in a flowing scarf. Try experimenting with mood next time you're on a shoot.

*Part Two | Composition Lines That Convey Moods in Your Image*

## 50. REFINED

» **1949 Chrysler, Mission Ranch, Carmel, CA, iPhone**

**Refined** means "elegant and cultured in appearance, manner, or taste."[16]

If you want to capture someone or something and make them appear refined, look for smooth curves. To change your flamboyant portrait to be refined, have your subject wear a suit, take away the flowing scarves, and comb their hair!

## 51. JAGGED, BRUTAL, HARD, VIGOROUS, MASCULINE, PICTURESQUE

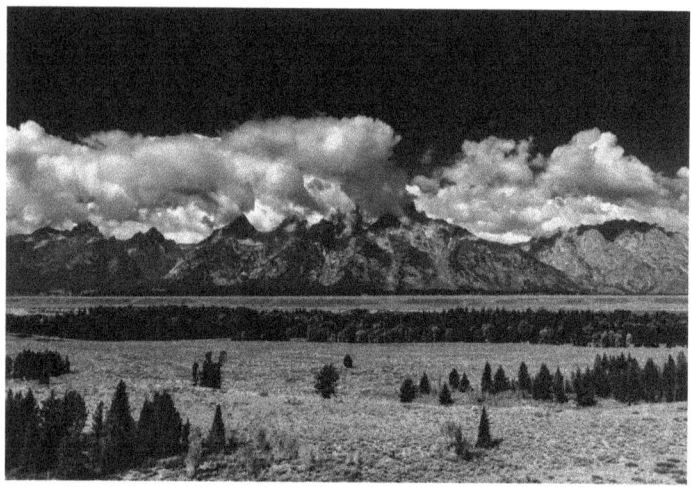

» **Grand Teton National Park, Wyoming**

Now, if you had your refined chap and you wanted him to look rugged and masculine what might you do? Tell him to skip shaving, wear some rough jeans or chaps, and put him next to a jagged setting like boulders or mountains. What if you're in NYC, and no mountains? No sweat, Central Park has some boulders you can take your subject to.

It's all about first seeing or visualizing the mood or feeling that you envision and using your imagination to create it.

## 52. CURVILINEAR, TENDER, SOFT, PLEASANT, FEMININE, BEAUTIFUL

» **Girl in a Large Hat, Caesar Boëtius van Everdingen, c. 1645–c. 1650, Courtesy Rijksmuseum, Amsterdam**

What a perfect example of curvaceous, feminine, and beautiful. Quite the contrast to the previous photo.

But what about a tree?

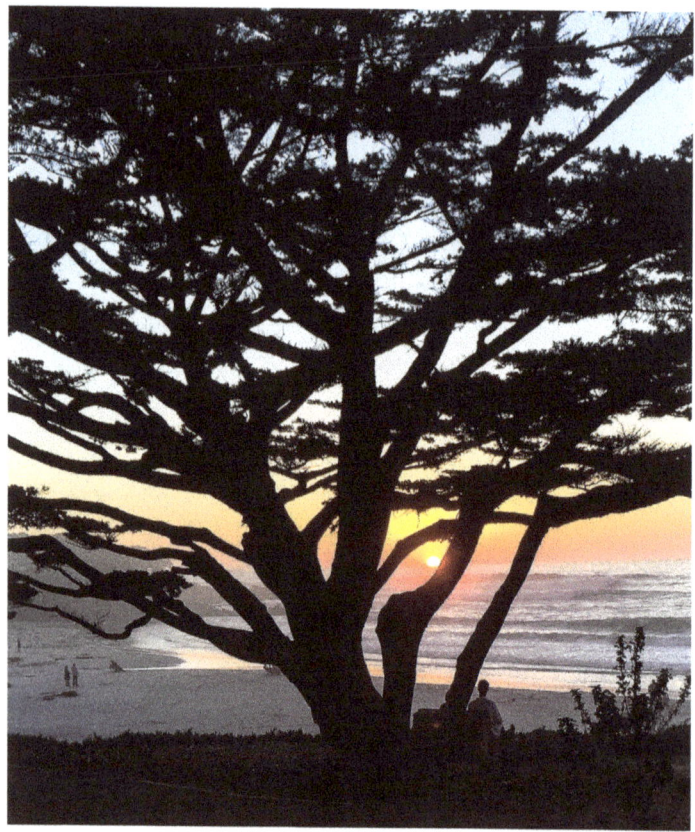

» **Cypress Tree, Carmel Beach, CA, iPhone**

Look for those curves if you want to express the beauty of your scene.

If you were taking a portrait and wanted to convey the feeling of femininity and tenderness, you might look for a background with these curved lines.

## 53. ROUGH, RASPING, GRATING

>> **Wave on Pebbles, Pescadero State Beach, CA**

A long exposure helps to capture the feeling of motion over the rocks, with rough edges on the waves and stones, you can almost hear the sound of the rocks being grated by the surf going in and out.

## 54. SMOOTH, SWELLING, SLIDING

» **Upper Saranac Lake, New York**

This image actually has three smooth lines with the mountains in the background, the swell of the wake, and the wave of the flag.

There's often going to be more than one mood line involved in any one image. This one has the upright flagpole showing stability, which doesn't conflict with the smoothness; in fact, it adds contrast (see #30) to the flowing lines.

## 55. DECREASING, CONTRACTING

» **Golden Gate Bridge, San Francisco, CA by Thomas Hawk**

The whole flow of the lines to the right is showing the bridge and landscape decreasing.

There's also an interesting juxtaposition (tool #30) with the curves of the clouds showing unstableness.

As you shoot, you can find many examples of multiple lines interacting with each other.

## 56. INCREASING, EXPANDING

» Beach at Dover, Francis Frith, 1891, Courtesy Rijksmuseum, Amsterdam

You can see how the photographer used the widening < shape to draw your eyes up the beach, to the buildings on the upper right, giving the feeling of increasing or expanding perspective.

## 57. DYNAMIC

» **Paw in Sand, Pescadero Beach, CA**

The upside down V lines give the image a dynamic feeling of motion around this single paw print. It is also an example of contrast (tool #30), combined with a bit of mystery—where are the other paw prints?

## 58. STATIC, FOCAL, FIXED

>> Ansel Adams' 8x10 Deardorff Camera, Carmel, CA

A play on words here, but the lens is the focal point of this image and tends to fix your attention on it.

Compare the circle of the lens with the Vs of the previous image, do they strike you as dynamic vs. static?

## 59. IN MOTION

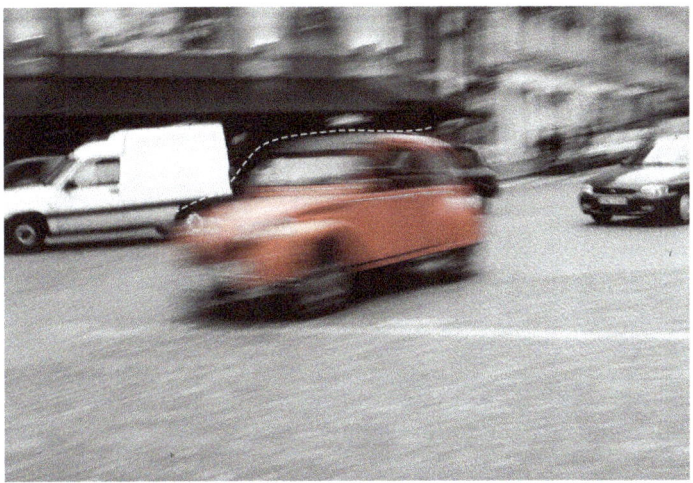

» **Red Citroën Deux Chevaux, Paris, France**

I wanted to come back from Paris with at least one image of these iconic French cars captured, and waited on a corner until this "Deux Chevaux" (meaning "two horses") flew by, so I could check it off my shot list.

The curved line the cars are following and the long exposure combined with it shows motion. I edited the image to desaturate everything but the red to increase the contrast and highlight the classic color of the car.

## 60. MEANDERING, CASUAL, RELAXED, INTERESTING, HUMAN

» **Rooftop View of Vats of Dye at a Leather Tannery, Fez, Morocco**

Life isn't always made up of orderly lines, but even in these meandering lines, there is relaxed, interesting humanness—you can't help but wonder what those vats are and how they are used and even how they are navigated by workers.

## 61. ERRATIC, BUMBLING, CHAOTIC, CONFUSED

» **Sculpture Outside of Sagrada Família, Barcellona, Spain**

Erratic, chaotic, and confused can be beautiful. Look at how the sculpture is contrasted with the graceful spires of the Gaudi temple on the left (see more about him at #80).

## 62. LOGICAL, PLANNED, ORDERLY

» **Gull Bay Boathouse, Upper Seranac Lake, New York**

Here you see orderly, planned lines, offset a bit by the slight diagonal of the longer oars, as though they were an afterthought and not quite stable (see #44).

## 63. FLOWING, ROLLING

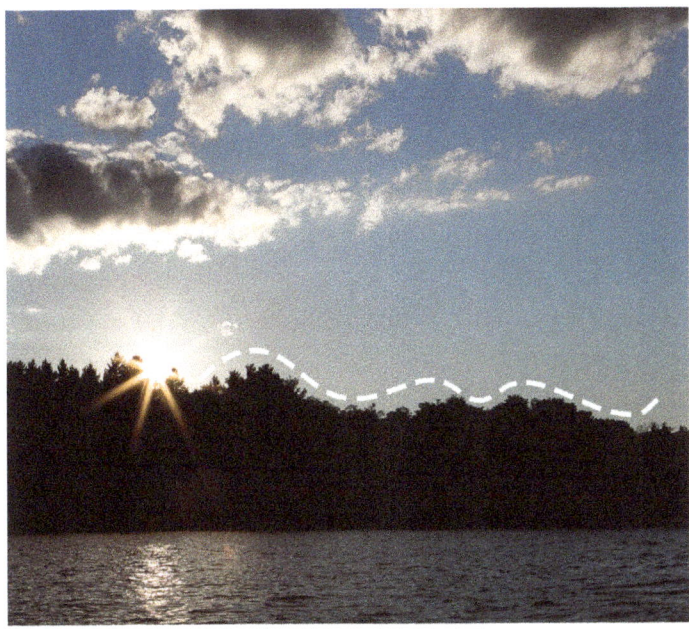

» **Upper Seranac Lake, New York**

This is similar to the S-curve, just turned on its side, but with the same sort of flow and rolling feeling. Everything in this image seems to be flowing left to right, almost rolling downhill slightly.

## 64. FORMAL, PRIESTLY, IMPERIOUS, DOGMATIC

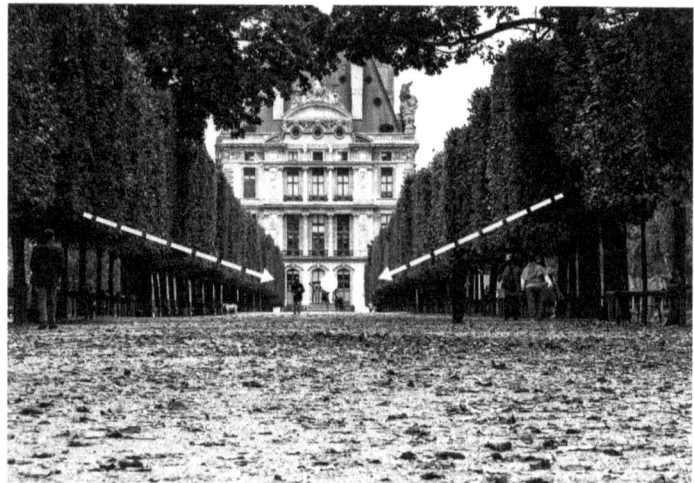

» Park, Garden, Promenade, Jardin des Tuileries, Paris, France

The Promenade certainly is formal with its precise lines directing your eye to the main building at the end.

Let's say you wanted to take a formal portrait and make the subject look slightly "imperious" (domineering or arrogant). You could place them in the promenade with a low camera angle, looking up at them (see #16). These are all parts of your tool kit as a photographer, to tell the story the way you envision it.

Go to AYPClub.com resource page for some examples of the great portrait photographers to see how they used moods to express what they wanted to show.

## 65. RISING, OPTIMISTIC, SUCCESSFUL, HAPPY

>> **Could be Elliot looking for ET, Carmel Beach, CA, iPhone**

It's easy to see that the upward curving line conveys feelings of happiness and success. By the way, want to make your own mood look like that upward line? Go find a tree or a hill to climb, just imitate the action of rising up and see what happens.

## 66. FALLING, PESSIMISTIC, DEFEATED, DEPRESSED

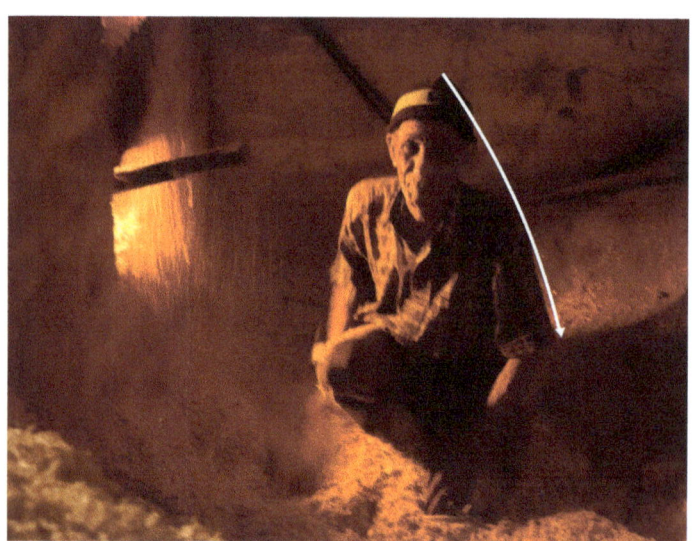

» **Man Tending Furnace, Fez, Morocco**

This man's whole body has a downward curve, showing defeat, as though he's fallen. Compare the two moods of this pair of images, with the boy reaching, exploring and climbing up, by contrast.

When you're out photographing, be sure not to get stuck in any one type of mood. Life has them all, so learn to see and capture them as they are.

## 67. INDECISIVE, WEAK

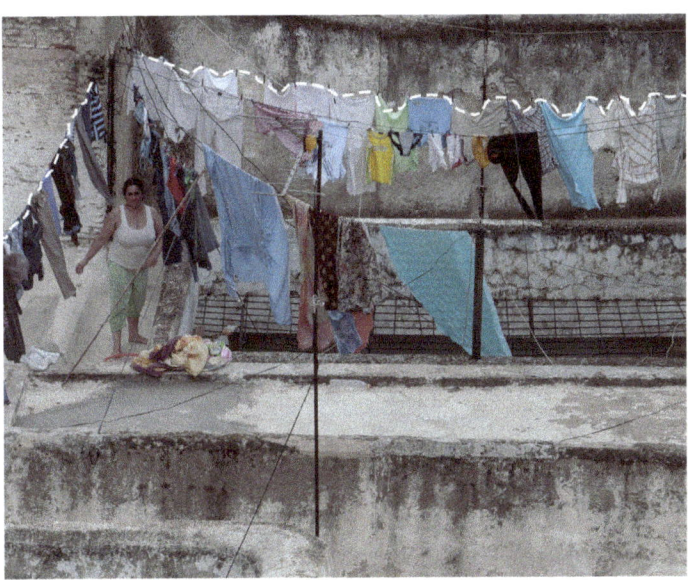

» **Woman Hanging Laundry, Fez, Morocco**

Keep in mind we're simply looking at lines and not passing judgment on our subjects. From what we see of the clotheslines, they show weak indecisive lines, mirrored by the similar lines in her environment.

These lines help to tell your story and can either add to the feeling you get from the subject or can be used to contrast the subject with the environment. Compare her body language with that of the doorman on page 132.

## 68. PROGRESSIVE

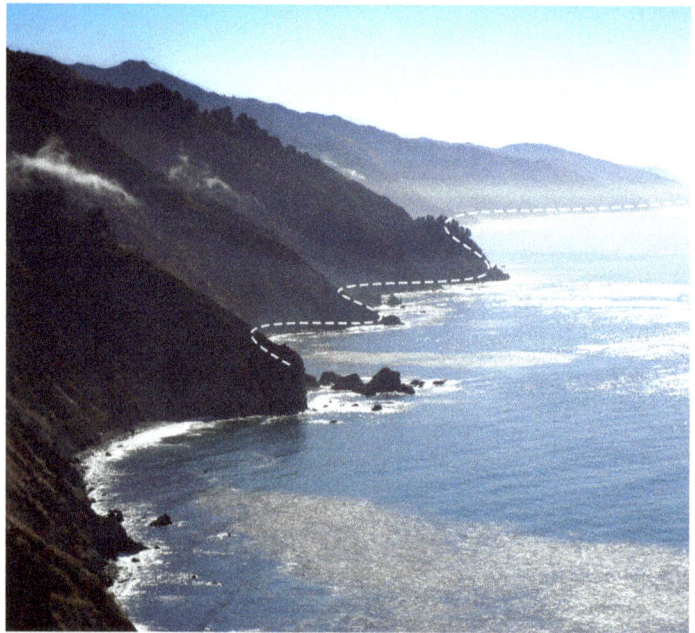

» **Coastline Looking South, Big Sur, CA**

The whole coastline of Big Sur seems to be progressively opening up wider as it heads south. This gives the feeling of expanding space through its widening turns jutting into the Pacific Ocean.

This is truly one of the most magical views you'll ever see. If you have a chance, come here and be prepared to capture many photographs.

## 69. REGRESSIVE

» **Ferns on the John Muir Trail, High Sierra, CA**

Each fern frond, with its group of leaves, follows a digressive (gradually reducing) pattern of lines; this is no less magical than the last, if on a smaller scale. It's worth noting that size and direction is often not a factor in the mood of the line, rather it is the character of the line that creates the mood.

# 70. RISE, ATTAINMENT WITH EFFORT, IMPROVEMENT

» Statue of Liberty, Liberty Island, New York Harbor

In this photo you can see a classic mood line that the whole world recognizes as showing attainment when they sail into the New York Harbor.

## 71. FALL, SINKING WITHOUT EFFORT, IMPROVEMENT

» **Vernal Fall, Yosemite National Park, CA**

It's interesting that this photo and the previous both show improvement as a result of rising or falling.

## 72. INDIRECT, PLODDING

» Devils Postpile National Monument, near Mammoth Mountain, CA

You could say this is "plodding" since the formation you're seeing was created by a lava flow about 100,000 years ago, give or take.

Both man and nature display every one of the lines we're going over, almost as though they are a pattern, or the DNA of life.

## 73. CONCENTRATING, ASSEMBLING

>> **Simón Bolívar's Signature, Octagon Museum, Curaçao**

You can tell from his signature alone that this was a great man who branded himself with the flourish at the bottom of his name. The concentrating loops exemplify that he was able to assemble and lead the bulk of South America to independence from Spain.

This is a good example of how one can live life itself as an art form. Every line and form you display to the world carries with it a mood or message.

## 74. DISPERSING, FLEEING

» **Salvador Dalí's House, Port Lligat, Spain**

Notice the outward spiral effect of the brushes, as they almost look like they are "fleeing" their containers.

Salvador Dalí's house is truly amazing, he literally turned every inch of it into a work of art. Notice the light bulb wrappers on the right; he put these on the legs of various chairs around the house. From this, you can get the idea of a creative spirit constantly looking for ways to make his environment more aesthetic.

## 75. BROKEN, INTERRUPTED, SEVERED

» **Rubicon Estate, Napa, CA, by Robert Holmes**

You'll see broken lines everywhere in this image of the trees, their shadows, and the vineyards beyond. The fact of their being broken and juxtapositioned with each other builds interest. Here we see we see art imitating life: going back to how Mr. Simonds used these lines in landscape design, and then in the aesthetics of this photograph.

## 76. DIRECT, SURE, FORCEFUL, WITH PURPOSE

⟶

» **Dancer with Chick Corea's Group, Berkley, CA**

This photograph is a great example of a direct and forceful line. There is not one speck of uncertainty in her forward motion that is both purposeful and graceful.

## 77. OPPOSING

» **Mapfre Tower, Barcelona, one of the tallest skyscrapers in Spain**

As you can see in this photograph, the opposing lines are the key to the design of the tower.

## 78. CONNECTING CROSSING

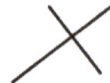

» **Learning Guitar, Los Gatos, CA**

You can certainly see the young lad connecting with the guitar in this photo. Look for crossed lines to illustrate the connection between two parts of your image. Also see the notes for Cross Composition (#28).

Part Two | Composition Lines That Convey Moods in Your Image

## 79. PARALLEL, OPPOSING WITH HARMONY

» **Horse Harmonizing in the Pyrenees, Spain**

The above photo is a great example of this tool. Even though they have opposing lines, the harmony is so obvious here.

## 80. EXCITED, NERVOUS, JITTERY

» Gaudí Wrought Iron, Park Güell, Barcelona, Spain

Antoni Gaudi was a visionary and genius architect of many buildings in Barcelona. He used the design shown in this photo at the entrance to the park, no doubt to intentionally create a feeling of nervous excitement upon entering. He was the master of lines and shapes, with his own organic style that was futuristic and beyond anything else being created in the early twentieth century.

## 81. OPPOSING WITH FRICTION

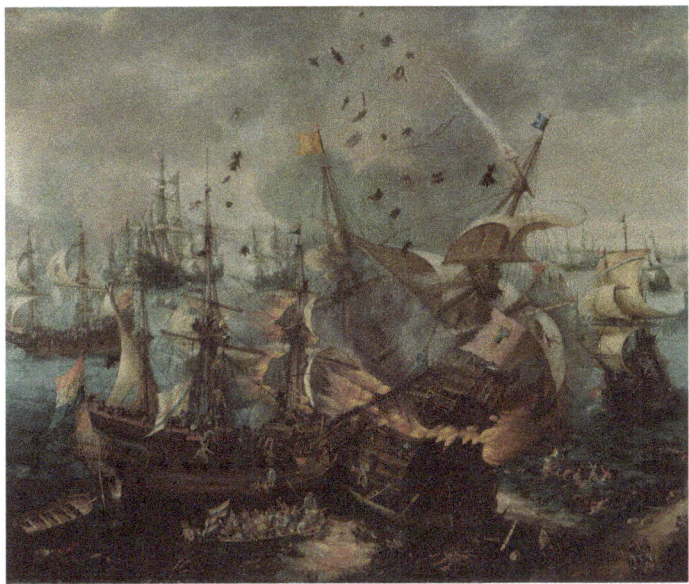

» **The Explosion of the Spanish Flagship During the Battle of Gibraltar, Cornelis Claesz van Wieringen, c. 1621, Courtesy Rijksmuseum, Amsterdam**

This photograph shows opposing lines with friction perfectly. You can almost hear and feel the battle in this painting showing strong lines of opposing friction.

## 82. DIVERGING, DIVIDING

» **Tree Over Road, Canyonlands National Park, Utah**

You can see multiple sets of diverging and dividing lines here: on the tree limbs and in the road that is diverging with an upside down Y.

Lines can be symbolic of a moment in your or your subject's life, as this was for me: I had just left Vermont in the northeast US and headed west, looking for answers to my life that I was soon to find in a big way. Your use of lines in an image-story can help you convey your message almost instinctively and deeply to your viewer.

## 83. GROWING, DEVELOPING

» Branch in Snow, Marlboro, Vermont

Even though it will be months before spring arrives in Vermont, you have the feeling of this branch holding its own against winter and awaiting its time to grow and develop when the thaw finally comes. This was taken shortly before the last photo when I headed west for that new adventure in my life.

# PART THREE:

# PUTTING YOUR TOOLS TOGETHER AND FINAL TIPS

### FINAL TIPS FOR PUTTING THESE COMPOSITIONAL TOOLS TO WORK

"IF YOU WANT TO TEACH PEOPLE A NEW WAY OF THINKING, DON'T BOTHER TRYING TO TEACH THEM. INSTEAD, GIVE THEM A TOOL, THE USE OF WHICH WILL LEAD TO NEW WAYS OF THINKING."

—BUCKMINSTER FULLER, ARCHITECT, AUTHOR

» **The Photographer's Workroom, Henry Pauw van Wieldrecht (possibly), 1903–1907, Courtesy Rijksmuseum, Amsterdam. This is what it took to create a photo 111 years ago!**

We've now covered 83 formats or tools for composition. As I mentioned in the beginning, there are many more that you can find by studying the works of masters, but the ones we have gone over will take you a long ways in expanding your compositional tool kit.

I'm going to give you some final tips that you can incorporate in your use of what you've learned:

A. Remember what I said in the introduction: "The urge to make pictures and share them with others runs deep within mankind."

B. Remember, this goes all the way back to cave paintings, with the same urge progressing forward in time using our modern cameras. But never lose sight of the depth of composition and the purpose it serves in communicating your ideas to others with the pictures you have created. In the end, the purpose of composition is to help you communicate to your viewer what you saw and felt.

C. With your composition you can be *passive* or *active*. Passive means you take what comes your way and try to make the best of it. This is like being a spectator at a sporting event rather than a participant. I encourage you to be active in your approach to photography: be willing to get in there and *direct* your shot. When working with people, interact with them and tell them where you want them to move, expressions you want, etc. Direct them actively.

D. If you're shooting natural scenes, move about and choreograph your shot, remember the advice from Camille Seaman at tool #17.

E. Think of the tools we have gone over as a "language." And similarly to broadening your vocabulary or learning a new language, you need to put the new words you've acquired into use so they become your own. This comes from practice, referring back to these tools and practicing again and again!

F. As I neared completion of this book, I spoke with Kim Weston (grandson of Edward Weston, one of the masters of twentieth century photography) about how he teaches

composition. Kim brought up some important points that I want to pass along to you:

a. It requires a conscious decision of your vision to create a photograph. Don't just press the shutter—get a definite vision and capture that. (You'll find much more about visualization in my book, *Advancing Your Photography*.)

b. Look at the whole frame of what you are capturing; especially pay attention to the edges. Less is more, so take out anything that doesn't aid in communicating your message.

c. Notice the *rhythm* of your photographs: where the viewer's eye enters and exits (see #28 "Eye Movement"). Look at how light moves through your photograph and where it takes your eye. If there is something that would pull the viewer's eye away from the desired flow through your photograph (such as a splotch of light or reflection in a lower corner), compose your shot to avoid it in your frame. This goes back to being active.

d. After you shoot, go back and look at your images on a computer when they are fresh in your mind and critique them yourself or with others you trust. Learn from what you just captured and use that knowledge in your next shoot. Do this over and over.

My final advice is to shoot often and put what you have learned here to continuous use. I'm hoping that many of you will want

to take the challenge of capturing each one of these tools in your own work and sharing them with our community (#AYPClub). And on that note, stay connected to our community (through youtube.com/marcsilber) to watch our huge library of videos, rounding out what you have learned here.

I wish you all the best—create amazing photography and stay in touch.

Marc Silber

## ENDNOTES

1 Oxford American Dictionary. "Composition." Oxford Dictionaries. Accessed February 27, 2018. https://en.oxforddictionaries.com/definition/composition.

2 Merriam Webster Dictionary. "Geometric." Merriam-Webster. Accessed February 27, 2018. https://www.merriam-webster.com/dictionary/geometric.

3 Stroebel, Leslie D., and Richard D. Zakia. *The Focal Encyclopedia of Photography*. Oxford: Focal Press.

4 Stroebel, *The Focal Encyclopedia of Photography*.

5 Excerpts from *Composition Made Easy* by William Palluth. Used with permission. © Walter Foster Publishing, an imprint of The Quarto Group. London, UK, 1989.

6 Palluth, *Composition Made Easy*.

7 ibid.

8 Encyclopedia Britannica. Britannica Concise Encyclopedia. Chicago: Encyclopaedia Britannica, Inc., 2006.

9 Palluth, *Composition Made Easy*.

10 ibid.

11 ibid.

12 Oxford American Dictionary. "Juxtaposition." Oxford University Press. Accessed February 28, 2018. https://en.oxforddictionaries.com/definition/juxtaposition.

13 Oxford American Dictionary. "Ethereal." Oxford University Press. Accessed February 28, 2018. https://en.oxforddictionaries.com/definition/us/ethereal.

14 Oxford American Dictionary. "Mood." Oxford University Press. Accessed February 28, 2018. https://en.oxforddictionaries.com/definition/us/mood

15 Oxford American Dictionary. "Dichotomy." Oxford University Press. Accessed February 28, 2018. https://en.oxforddictionaries.com/definition/dichotomy

16 Oxford American Dictionary. "Refined." Oxford University Press. Accessed February 28, 2018. https://en.oxforddictionaries.com/definition/refined

17 Everett - Art llustration ID: 452827732. *Shutterstock.* Wheatstacks, Snow Effect, Morning, by Claude Monet, 1891. https://www.shutterstock.com/image-illustration/wheatstacks-snow-effect-morning-by-claude-452827732?src=library. (Accessed March 29, 2018.)

# ABOUT THE AUTHOR

» iPhone Selfie, Mission San Carlos Borroméo del río Carmelo, Carmel, CA,

Marc Silber is the author of the number-one bestselling book *Advancing Your Photography*, an award-winning professional video producer, photographer, and photography educator who has been successfully working in the field for decades. Marc combines his passion for the visual art of photography with his love of life.

He started out learning darkroom skills and the basics of photography at the legendary Peninsula School in Menlo Park, CA in the '60s, and moved on to hone his skills to professional standards at the famed San Francisco Art Institute, one of the oldest and most prestigious schools of higher education in art and photography in the United States.

Since then, Marc has been an dedicated educator; he began his teaching career at the age of nineteen at the National Outdoor Leadership School, teaching mountaineering. When teaching a life-or-death subject such as mountaineering, one learns how to make sure the students understand the material; when Marc moved into teaching photography in workshops all over the country, he became renowned as an engaging and helpful speaker and coach, as his greatest joy comes from helping others.

Marc has embraced the digital age with a highly popular YouTube show also named *Advancing Your Photography*, which has won several Telly Awards and other recognition for his work.

This new book on composition, *The Secrets to Creating Amazing Photos*, is a distillation of all the pro tips and wisdom from his YouTube series, coupled with his research of the master artists in a format you can take with you and refer to constantly when you are out creating your photographs.

www.ingramcontent.com/pod-product-compliance
Lightning Source LLC
Chambersburg PA
CBHW040107180526
45172CB00009B/1264